an advanced guide to digital photography

AVA Publishing SA
Switzerland

An AVA Book
Published by AVA Publishing SA
Chemin de la Joliette 2
Case postale 96
1000 Lausanne 6
Switzerland
Tel: +41 786 005 109
Email: enquiries@avabooks.ch

Distributed by Thames and Hudson (ex-North America)
181a High Holborn
London WC1V 7QX
United Kingdom
Tel: +44 20 7845 5000
Fax: +44 20 7845 5050
Email: sales@thameshudson.co.uk
www.thamesandhudson.com

Distributed by Sterling Publishing Co., Inc. in USA
387 Park Avenue South
New York, NY 10016-8810
Tel: +1 212 532 7160
Fax: +1 212 213 2495
www.sterlingpub.com

in Canada
Sterling Publishing
c/o Canadian Manda Group
One Atlantic Avenue, Suite 105
Toronto, Ontario M6K 3E7

English Language Support Office
AVA Publishing (UK) Ltd.
Tel: +44 1903 204 455
Email: enquiries@avabooks.co.uk

Copyright © AVA Publishing SA 2005

ISBN 2-88479-052-7

10 9 8 7 6 5 4 3 2 1

Design: Bruce Aiken
Picture research: Sarah Jameson

Production and separations by
AVA Book Production Pte. Ltd., Singapore
Tel: +65 6334 8173
Fax: +65 6334 0752
Email: production@avabooks.com.sg

an advanced guide to digital photography

vincent oliver

contents

'Great White Shark' by Sue Flood

introduction

There is no questioning, that after **160** years, photography has established itself as a mainstream art form. Evidence of this can be seen in major art galleries throughout the world, where photographs are displayed alongside traditional forms of art. More encouraging is the fact that collectors are paying premium prices for photographic prints, with some contemporary photographs selling for thousands of dollars. Photographers have had to work hard for artistic recognition. Now this has been achieved, along comes the next art form – the digital image. The digital image is unique in as much as it seamlessly crosses many boundaries of traditional art. A digital image can be a series of 'brush' strokes or it can be a subtle or heavily manipulated photograph that bears little resemblance to reality. Photographers now share the luxury that has previously been the domain of the artist; total control over all aspects of the image creation process. Distractions can be removed from a picture, colours changed, exposures altered and other elements added. A photograph can now be treated as an infinitely adjustable electronic canvas.

From its early beginnings photography has undergone many radical changes, from single-shot, monochrome, glass plates, to convenient colour-roll film. Yet it is only within the last few years that we have witnessed a complete overhaul in the method we use to capture pictures. Nothing has changed the actual process of taking the picture so that all the same techniques perfected with film photography can still be applied. The difference now is that pictures are captured electronically using a light-sensitive **CCD (Charge Coupled Device)** rather than coated emulsion. Film is rapidly being superseded by chips and circuitry, the traditional wet-chemistry process will eventually become yet another old process, alongside Gum Bichromate, Bromoil and Albumen prints. Some photographers still have their heads buried in the sand when it comes to digital matters, under the misapprehension that digital is inferior. They are wrong. A digital image can achieve a quality that not only equals but surpasses a film image, and it's getting better all the time.

There is a steep learning curve involved in the use of imaging applications such as **Photoshop** and a photographer must invest a considerable amount of time to learn new techniques and skills of image manipulation and digital file management. Digital photography is much more than just cleaning up pictures. In the hands of a creative photographer it's a powerful tool waiting to be unleashed.

This book informs and assists photographers who are keen to work digitally while keeping the process of creating pictures the priority.

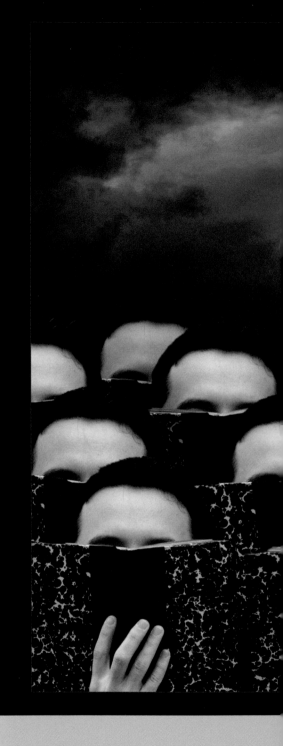

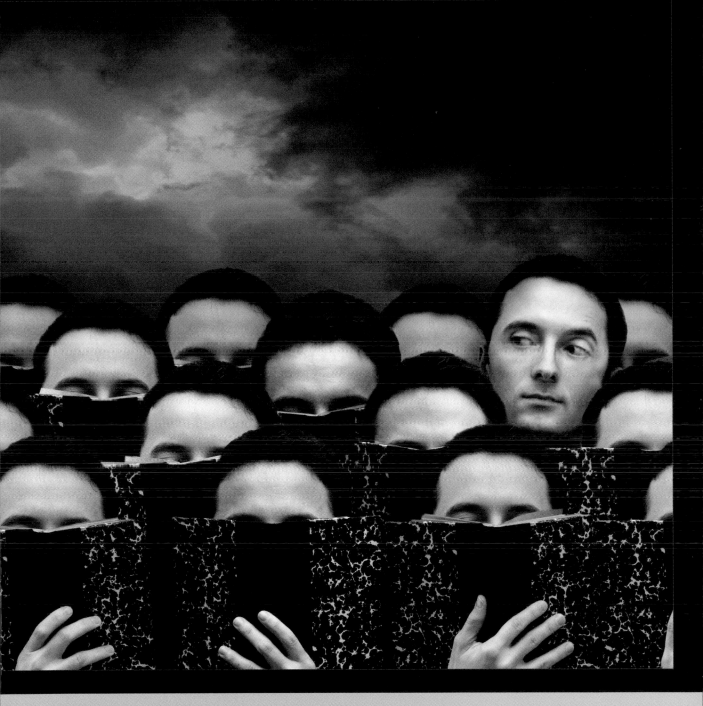

'The Exception' by Jean-Sébastien Monzani

introduction
The theme of the
spread and an
overview of the
techniques included.

how to get the most from this book

This book is divided into six chapters: The Equipment, Image Management, Manipulating and Retouching, Shooting Digitally, Digital Masters and Digital Presentation. Although each section assumes a sound knowledge of the usual photographic techniques, it is not assumed that the photographer will have an in-depth working knowledge of digital techniques. Wherever possible we will show you how tried and tested photographic techniques can be utilised with digital photography.

Each spread contains numerous tips and techniques together with details of how the sample images were created. This information should provide an ideal starting point for any reader wanting to progress their own photography. The book is not designed to be read from start to finish – although it will make sense like this – rather the reader should feel free to dip in and out of any page to learn something new each time.

Computer jargon has been kept to minimum and a glossary at the end of the book helps keep information crystal clear. As digital imaging relies on working with a computer, advice is also given on keeping your hardware in top working order.

Where required, shortcut keystrokes marked as Ctrl + M (Windows) or Command + M (Mac) are included. These will speed up the workflow and readers should spend some time to learn them. Menu commands are listed as (Menu – Image > Adjustments > Curves), or as a shortcut keystroke (Ctrl + M).

The Equipment section starts by comparing film with digital files and moves on to guide the reader through the hardware requirements of digital cameras, computers, scanners, printers, and other essential hardware.

Image Management advises on the most efficient methods for keeping consistent colour, keeping track of the thousands of digital files with strange names (DCS_2345 etc), and essential software.

Manipulating and Retouching looks at various techniques for retouching digital images, correcting colours, and salvaging pictures that may have ended up in the 'Trash'. Other sections include masking, adding new backgrounds, montage, panoramas, and special effects using third-party software.

The Shooting Digitally chapter focuses on real world photographic scenarios. This section is illustrated with instructional step-by-step photographs to help you achieve similar results or to inspire you to develop the ideas further. The contributing photographers have supplied many valuable tips and shortcut techniques throughout.

In the Digital Masters section we take a look at how seven photographers have embraced digital technology in their everyday work and they give us an insight into how their work has changed.

The final section looks at the various options available for exhibiting images.

shooting to a brief

Every photographer likes to do his or her own thing, having the freedom to roam around and take pictures of things that interest you has to be the ultimate luxury. But the going gets tough when you have to shoot to fit a layout and come back with striking images.

the brief

Nick Scott is a fashion photographer who has worked for most of the leading fashion magazines. He was commissioned by the beauty editor of Italian 'Vogue' to do this shot.

They were already running late with publication deadlines and so everything was a bit rushed. The brief from the editor was rather vague, other than that the image was to feature a new lipstick colour. The first task was to cast the model, about 20 girls were called in, giving Nick the opportunity to see the models' lips at first hand. Naturally it was important that the mouth was right as it was to be the focal point of the shot. Although most photographers make an initial selection from models' cards and agency books, it is still important to see the models at first hand since it is not uncommon for portfolio pictures to be one or two years out of date.

section title

Each spread is divided into sections with clear subheadings. Where a picture has been disected the headings 'capture' and 'edit' are used. 'Capture' explains the background details up until the actual moment the picture is taken. Including the choice of equipment and the context of the shoot. The 'edit' section explains the process that the image has been through once in computer, outlining the stunning results that the digital photographer can create post-capture.

A detailed view of a dialogue box or full screen will show the settings to use. These are useful guides but we encourage you to experiment with the settings so you can explore various effects.

Throughout the book there are many quick tips; from shortcut keystrokes to how to apply an effect quickly.

The main picture on each spread is the finished picture. Before commencing any step-by-step exercise, take time to examine the picture to see if you can work out how the effect has been achieved.

ture

...the model was selected, a ...t studio was booked. The ... was for a Spring/Summer ... and a light touch was ... A hat was planned to ... the prominence of the ... and to concentrate attention ... mouth, summery clothes ... also chosen. In the event ... was gloomy, none of the

hats worked and the clothes didn't really cut it either. The beauty editor was in Milan and Nick was in London, both trying to sort out a solution on the phone – pretty much a recipe for disaster. Nick realised that some drastic post-production was going to be necessary.

> **Use Adobe 1998 colour space, this is the industry standard for publication.**

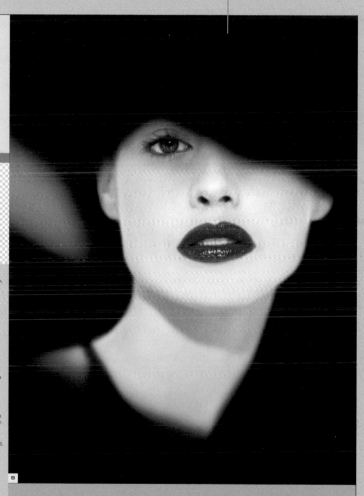

effect and suggested that the model's right shoulder be dropped a little. The chosen image was drum-scanned and the shot manipulated in Photoshop. A provisional low-resolution version was emailed for approval. A few adjustments were made and then a final high resolution version was posted on Nick's server so that it could be downloaded ready for publication.

4 layers

1/ The original scanned picture, without any adjustments.

2/ Shadows were created by making a freehand selection using the Lasso tool before filling with black. Adding a feathered edge meant that there were no harsh lines.

3/ The shoulder was reshaped using the Liquify filter in Photoshop, which enables you to pull and push images into shape.

4/ The left eye was copied and pasted as a new layer and then the shadow was reduced with a Curves Adjustment Layer. The lips were also copied and pasted as a new layer, these could now be adjusted independently of the rest of the picture using a Hue/Saturation Adjustment Layer.

5/ For the final image the model's skin tone was lightened, the neck area was cleaned up and an overall soft-focus effect was applied. The lips and eye were left sharp.

Make-up: Anna Scott.

...ocessed film was scanned ...selection of the best shots ...emailed to the editor. Over ...one they made a choice ... on the mouth and then ...sed what could be done ...e the shot work. Nick ...d by roughly making a ...shadow over one eye and ...he lighting on the other. ...g with low-resolution files ...t possible to email these ...s as they were talking on ...one. The editor liked the

3 liquify

captions

The image captions detail the processes shown in each image.

spread title

1 the equipment

'Easter Egg Dip' by Heather McFarland.

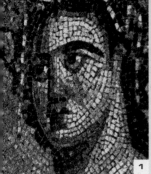

1/ Using fragments of pure colour to create a picture is nothing new. This ancient Greek mosaic is made up from small pieces of pottery. When viewed from a distance the image seems continuous, but close up the individual tiles become noticeable – rather like grain and pixels.

! Memory cards are not effected by airport x-ray machines, which can effect film.

! You can't overwrite a full memory card – images must be deleted or the card formatted to clear images. This acts as a useful safety feature and guarantees you won't lose any pictures.

grain to pixels

There is nothing new about working with pixels (taken from the words 'picture elements'). The Romans and Greeks used pixels, in the form of mosaic tiling, to create exquisite decorations and floors. The impressionist painter Georges Seurat pioneered an art technique called pointillism. His paintings are made up of very short paint strokes or dots. From a distance the eye cannot discern the individual mosaic tiles or dots and they merge to create variations of tone in the picture.

Pixels do a similar job; each pixel is assigned a colour from a large palette of 16.7 million or more colours and is given a unique place in the picture – recorded using X and Y coordinates. The digital image is made up from millions of tiny pixels. The more pixels used, the finer the resolution becomes, and the image detail is greater as a result. Photographers have been using a similar dot technology from the beginning. Photographic film uses light sensitive silver particles which create the photo, this is called 'grain'.

A photograph is 'grainy' when the tiny silver particles become visible. Grain is not usually visible to the naked eye, but sometimes photographers deliberately emphasise the grain for effect, or to enhance a picture. A digital photograph is made up from pixels and, as with film, these should not be visible to naked eye. When they do become visible the picture is referred to as being 'pixelated'. This normally means that the image resolution is too low. This is generally regarded as unacceptable, however, pixels can also be used for effect.

Another form of grain is image noise. This is unwanted, random, multi-coloured spots which are usually generated through long exposure times or by over-correcting an image, this is not to be confused with pixelation.

Images captured with a digital camera are stored on removable memory cards. There are several card types, including: Compact Flash, SmartMedia, MicroDrive, Secure Digital, XD media and Memory Stick. Most digital cameras usually only accept one card type, but there are a few professional cameras that accept

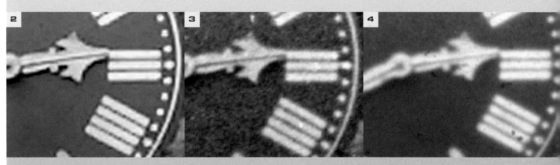

2/ The clear advantage that digital photographs offer is the lack of grain. The picture of the clock face was shot using a Canon 1Ds camera with 50mm lens.

3/ This picture was shot using ISO 100 negative film stock – the film grain structure is starting to break up the image.

4/ This picture was shot using transparency film stock – although the film grain is smoother, the dust and flare caused by scanning have degraded the image.

5/ 6/ Film grain will dominate when enlarged. In this example, the film was scanned in at 3200dpi to produce a file size of 37MB. This is the maximum resolution for quality 35mm film scans. Scanning in at a higher resolution will result in more pixels per clump of grain, there is no advantage to be gained. The 37MB file would produce a 15 x 10inch print at 300dpi.

Photograph by Vincent Oliver

7/ 8/ Digital photography is not all plain sailing either, over-enlarge the image and you will see the pixels (pixelation). The only cure for this is to use a higher-resolution camera. A Nikon D1 was used for the sample here, the 7.5MB file would produce a 6 x 4inch print at 300dpi.

Photograph by Vincent Oliver

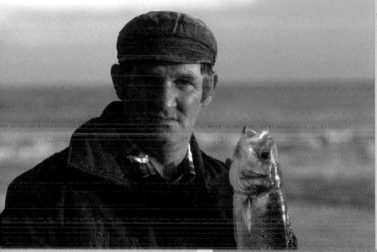

than sufficient. For professional SLR digital cameras, cards with a capacity of 256, 512MB or 1GB+ should be considered. For reasons of precaution it is far better to take several smaller cards on assignment than one large card.

> **!** **Keep memory cards in a protective case to protect the delicate contacts from moisture and dust.**

two types. SLR cameras generally use Compact Flash and MicroDrive. A MicroDrive is a miniature hard drive that slots into a Compact Flash card slot. Although it offers a high capacity at a reasonable cost, it is a mechanical unit and so is therefore more likely to fail. Consumer cameras tend to use SmartMedia or Secure Digital cards.

Memory cards vary in capacity from 8MB to 4GB. Obviously more images can be stored on the larger capacity cards and this is particularly important if shooting in TIFF or RAW mode. For most consumer cameras a memory card with a capacity of about 128–256MB will be more

! Avoid over use of the LCD monitor – this causes a heavy drain on the batteries.

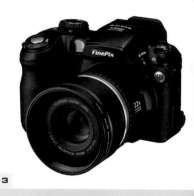

3

digital cameras

There are five main categories of digital cameras. It is important to think carefully about what kind of results you want to achieve before you decide what camera you are going to purchase.

entry level

The basic entry level 'point and shoot' cameras are generally suitable for emailing, websites, multimedia, or other presentation work. Most cameras at entry level have a fixed lens, low resolution up to 2Mp and a limited, or fixed memory. Some offer a digital zoom, which sounds impressive but actually means the camera magnifies the image internally – including the pixels. Cameras in this category have many limitations and as such are not suitable for advanced digital photography. However, as with the modestly-priced Russian Lomo film camera, these cameras can be exploited for their limitations and used for 'artistic' creations.

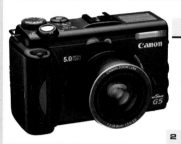

2

compact

Outwardly compact-style cameras look and handle like any 35mm film camera and it's this camera that is responsible for the digital revolution. These cameras have a resolution between 1–5Mp and will produce quality prints up to A4 in size. They have a better optical system than the entry level offerings. Compact digital cameras are small and easy to carry around. They are the ideal camera for holiday 'snapshots' and are more than adequate for capturing everyday events. A professional photographer may also use this small camera for reconnaissance work prior to an assignment. The main disadvantage with the camera is a slow response to fast-moving action, shots will be missed time after time due to the camera setting itself up.

prosumer

The prosumer camera is an SLR-style camera with a fixed zoom lens in the 28 to 105mm range offering a resolution between 4–8Mp – more than sufficient for producing prints up to A3 in size. The prosumer camera is a hybrid between a compact and a SLR camera and generally has an impressive specification. Although considerably more expensive than a compact-style camera and many sophisticated 35mm film cameras, the prosumer camera is limited to just one lens. The camera may have a monitor in the viewfinder which makes viewing the picture very easy in bright conditions (viewing an LCD screen on a sunny day is near impossible). This camera would be an excellent choice for a hobbyist or as a back-up camera for a professional photographer.

! Carry two spare batteries with you at all times. Most batteries can be quickly charged in one hour. In cold conditions a battery's life will be shortened considerably.

! Many digital SLR cameras may be compatible with your existing 35mm film camera's lenses.

digital back

The digital back is a back containing a CCD sensor that fits on a medium- or large-format camera in place of the usual film holder. The digital back comes in two forms; as a self-contained unit, or as unit that has to be connected to a computer via a Firewire cable. The self-contained version is basically a digital camera without a lens. It has a built-in LCD screen and accepts Compact Flash memory cards.

! Shield a SLR camera when changing lenses, to help to keep the dust out of the casing.

slr

The SLR camera falls into two groups. The first is the entry level SLRs, due to their pricing these are becoming very popular with the hobbyist and professional photographer alike. The second group contains the Pro SLRs. These have a resolution between 6–14Mp. Photographers moving over to digital will be at home with this camera type from the outset and as an added bonus, many cameras offer full compatibility with existing film camera lenses.

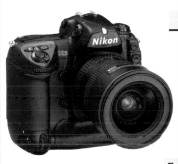

other

With the increasing popularity of DV (Digital Video), there is no reason why a DV camera can't be used for capturing photographs. Some have the ability to shoot in digital photo mode which stores a high-quality still image directly to DV tape. In frames mode, the camera can shoot up to 25 frames per second, this in effect gives the camera a high-speed motor drive so that you can select the right picture from a sequence of shots. Other DV cameras use a memory card to capture single shots.

1/ An entry-level camera from Olympus.

2/ A compact camera from Canon.

3/ A prosumer camera from FujiFilm.

4/ An Imacon iXpress digital film back.

5/ A SLR camera from Nikon.

6/ A CCD sensor.

sensor size

Advanced SLR digital cameras look, and feel, like 35mm film cameras. There are two types: a camera with a full-frame sensor that gives the same angle of view as a 35mm film SLR camera, and a camera with a sensor that gives the effect of a 1.5X magnification (it doesn't actually magnify, it just crops the sides of the image). The advantage of having a full-frame sensor is that you can use the camera and lenses as if you were shooting with conventional 35mm film cameras. All your wide-angle lenses will have the same angle of coverage. This is not the case with cameras that use a smaller sensor, these cameras require extra-wide lenses to give the same angle of view. Nikon and other manufacturers are now producing extra-wide lenses for their digital cameras. The bonus is that at the long end of the lens scale, the images are going to appear magnified. Once you have used a camera for a while, the issue of what focal length you're using is soon forgotten, especially if you are using zoom lenses.

lens conversion tables

Full frame (35mm and digital)	Normal angle of view (Horizontal)	Digital camera with 1.5X magnification	Effective angle of view (Horizontal)
14mm	104' 15'	21mm	80' 29'
17mm	93' 16'	26mm	69' 45'
20mm	83' 58'	30mm	61' 17'
24mm	73' 44'	37mm	52' 33'
28mm	65' 28'	43mm	45' 52'
35mm	54' 25'	53mm	37' 24'
50mm	39' 35'	76mm	26' 39'
85mm	23' 54	130mm	15' 52'
105mm	19' 27'	160mm	12' 52'
135mm	15' 11'	206mm	10' 01'
180mm	11' 25'	274mm	7' 31'
200mm	10' 17'	305mm	6' 46'
300mm	6' 52	457mm	4' 31'
400mm	5' 09'	610mm	3' 23'
500mm	4' 07'	762mm	2' 42'
600mm	3' 26'	915mm	2' 15'
800mm	2' 34'	1220mm	1' 41'
1200mm	1' 43'	1830mm	1' 07'

1/ A laptop computer is handy on location as you can monitor your shoot. The screen is not usually precise enough, however, for accurate colour work.

2/ A Dell desktop computer together with flat-screen monitor.

3/ An Apple iMac with 20 inch screen. These are popular and break away from the usual desktop towers.

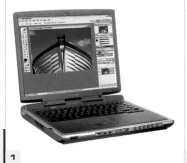

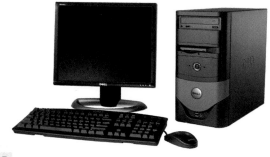

computers

1

2

At the centre of a digital photographer's working environment is the computer. This comprises of a Central Processor Unit (CPU), Memory, or RAM (Random Access Memory), graphics card, hard drive and CD drive. Almost all off-the-shelf computers are usable for image manipulation, but as with camera gear you have to tailor the equipment to suit your own needs. Computing is a numbers game, in theory the bigger the number the better the system is going to perform, but don't be talked into buying things that you don't really need. Here are a few recommendations for a digital imaging set-up.

CPU

The CPU is the part that does millions of calculations every second and sends the results to the graphics card for display. Digital files are made up from very large chunks of data so a fast processor is essential for efficient working. The speed of a processor is measured in megahertz (MHz). Essentially the higher the number, the faster the CPU processes the image data. Fast processors come into their own when applying plug-in filters to large files.

graphics or video card

The card should be able to display 24 or 32 bit graphics at a minimum screen resolution of 1024 x 768mm or more. Most cards have a built-in processor, some older or cheaper cards use the computer's CPU. A built-in processor takes the strain away from the CPU when large chunks of data need to be processed. For fast screen refresh rates the card should have 64 or 128MB of built-in video RAM.

RAM

Images are temporarily stored in RAM whilst work is in progress. When the computer is turned off all the information that is held in RAM is lost. For efficient image manipulation you should have at least 512MB, or preferably 1GB of RAM. Fitting extra RAM is very simple and will benefit your workflow by producing a marked improvement in speed. You'll know when you need extra RAM as your computer will be constantly using its virtual memory.

hard drives

Think of the hard drive as a large filing cabinet for storing images, data, applications, and the Operating System (OS). Drives come in a variety of speeds, the most common are 5400rpm or 7200rpm. This is the rate at which the disk spins. The disk should also have a high data transfer speed which enables image data to be transferred more quickly (this is important when virtual memory is being used). Digital images eat up disk space. If you are working with high-resolution images then each file could be 30MB or more in size. Buy a hard drive with at least a capacity of 80 to 120GB. The other option is to use an external hard drive, these are handy for short-term back-up or for transporting large files between computers.

mac v windows

Mac or Windows is an argument that crops up time after time. Both computer systems do the same job. Photoshop on a Mac behaves in exactly the same way as Photoshop on Windows. Once you get used to the operating system there isn't any advantage that one has over the other. If your budget is limited then you are going to get better value for money with a PC running Windows. Make sure the PC has the latest version of Windows for full colour management support.

! Photoshop uses its own **Virtual Memory** called a **scratch disk**. The scratch disk should ideally be a second drive, or a large clear area of disk space. You can assign up to four scratch disks via the **Photoshop preferences**.

3

! Back up your pictures to **CD/DVD** regularly – hard drives can fail after time. Don't be tempted by bargain **CD/R** disks – your pictures are worth too much to risk losing.

4/ A TrackBall mouse will save a lot of arm work on your desktop, but it's not ideal for retouching work

5/ Graphic tablets are available in many sizes, an A5 tablet is sufficient for image editing.

4

5

mice and other input devices

Whilst it is possible to do image manipulation with a mouse, the better solution is to use a graphics tablet. This is a pressure-sensitive pad which uses a special pen to transfer brush strokes to the screen. The tablet senses where the pen is, how much pressure is being applied, and translates this into a hard or soft stroke. For anyone who is serious about digital imaging a graphics tablet is an essential item. These come in various sizes including A6, A5, A4 and A3. A large tablet size is not necessarily better for digital imaging, an A5 size gives as much accuracy as you need for digital manipulation.

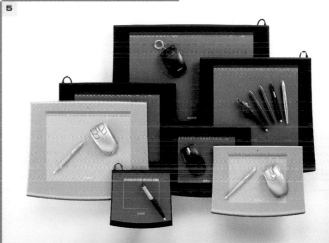

ports

A computer needs to send information to other devices such as printers and scanners. The two main port types are USB 2.0 (Universal Serial Bus), and Firewire (IEEE1394). Both of these allow hot swapping (this means you don't have to turn off your computer when you connect, or disconnect, a device). Most computers usually have two USB ports. To connect more devices you will need a USB hub, which provides up to seven extra ports. Firewire allows several devices to be daisy-chained together, but make sure that the device(s) have both in and out facilities. Hubs for Firewire are also available.

cd/dvd writers

The CD/DVD writer is perhaps the most important storage medium for digital images. CD writers come in a variety of speeds; 16X–52X. Look out for the read and write times – generally CD-R/W drives read much faster than they can write.

! USB 2.0 and Firewire are the most common ports. If your computer hasn't got one then you can always fit a **PCI card** with the ports, but make sure your **OS** supports it.

flatbed scanners

A flatbed scanner is the most convenient solution for scanning old photographs and other printed materials. Photographs are laid on a glass plate and a moving CCD array comprising of three rows of pixels (RGB) scans the picture. Think of a flatbed scanner as being a very sophisticated photocopier. The most popular size is A4 which will scan all photographic prints up to 10 x 8inch. Prices for these range from £50 upwards. Expect to pay between £250 and £500 for a good-quality scanner. A3 flatbed scanners are generally of more use to the design industry than photographers.

Many current flatbed scanners also include a Transparency unit, enabling positive and negative film scanning. Film size options vary, but most scanners will accommodate 35mm, 120, and 5 x 4inch films. Combination scanners are gaining in popularity

scanners and scanning

The most economical way to get started in digital photography is by scanning existing film or prints. A scanner is the crossing point for many photographers wanting to move to digital from film photography. Once the image has been scanned then the picture can be manipulated, printed, placed on the web, or distributed on CD.

! All scanners offer a sharpening feature – without it scans can look almost out of focus. However, sharpening on most scanner software can be over-generous. Turn off the Unsharp Mask on the scanner and apply it in your imaging application for a more controllable result.

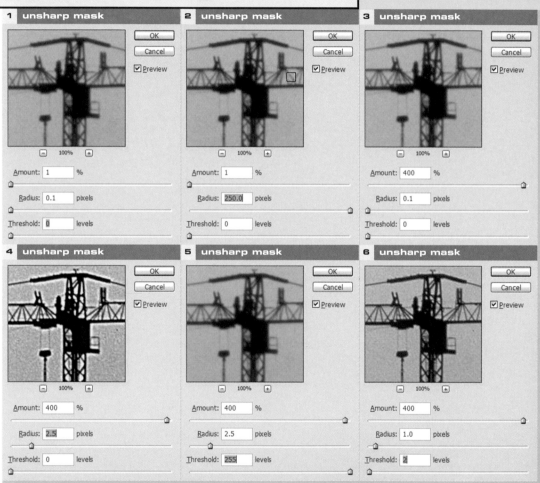

1/ No USM sharpening has been applied.

2/ The Radius value has been increased to 250, but on its own it has no effect on the image.

3/ The Amount value has been increased to 400, but again without the Radius value it has no effect.

4/ The Amount has been left at 400 and the Radius has been increased to 2.5. Now halos are appearing around the crane.

5/ To remove the halos, a Threshold value of 255 has been added, but this has cancelled out the Amount and Radius values.

6/ To get the best result from this image the following values were used. Amount 400, Radius 1, Threshold 2. Depending on the file size, different values will apply, for a small image values of 75, 0.5 and 1 will work better.

and offer a high film scanning resolution (3200–4800dpi). The high resolutions are necessary for 35mm film, but with roll and sheet film 3200dpi will produce large file sizes. The specifications on many current flatbed scanners are very high, and they may eventually drive out dedicated film scanners. You may see scanners offering an optical resolution of 3200–9600dpi maximum, the second figure is an interpolated size. This means that the scanner's software will generate extra pixels to give a larger file. Avoid using the interpolated size, they tend to lack sharpness and you will generally get better results by up-sampling the image in Photoshop or by using other image-editing software. It is important to look out for true optical resolution.

! **Digital ICE will virtually remove all dust from a slide or colour negative, but be aware it does not work with B&W negatives or Kodachrome films. This is due to the silver grain particles reflecting back into the IR beam.**

film scanners

Although some of the higher-resolution flatbed scanners do an excellent job with 35mm film, a dedicated film scanner will generally produce a better result. A good quality film scanner should have a minimum optical resolution of about 3000dpi. At 3000dpi the scanner produces a file size of around 33MB which is probably the optimum resolution for 35mm film. Scanners offering a higher resolution are not necessarily going to give an increase in image quality, just more pixels per clump of film grain.

There are a few 120-roll film scanners but these are expensive. The difference in quality between a dedicated medium-format film scanner and a good transparency unit on a flatbed scanner is not obvious. The main difference is that film scanners have a higher Dmax figure (this means more detail in the shadow and highlight areas).

Drum scanners are the ultimate in scanners, but they also carry a hefty price tag. Film is wrapped around a clear drum, and held in place with a special oil. The drum is spun at a high speed and the image is read by a laser. The most economical way to obtain a drum scan is to use the services of a colour lab.

Current scanners use either a USB or Firewire port. Both of these ports claim a faster transfer of data, but in truth, neither is faster. High-end professional scanners may use a SCSI connection which you can't hot swap.

Many scanners have a dust removal facility which scans for small dark spots and blends them with the surrounding colours. The problem with this solution is that it doesn't know the difference between a spot of dust or a bird flying in the sky. Other small details within the picture can also end up being blended. More sophisticated dust removal is handled by a combination of hardware and software called Digital ICE and FARE. Here the scanner makes two passes over the image, the first scans the image, the second scans the surface with an infrared beam and creates a 3-D map. With this information the software knows which parts of the picture are image and which are dust. A similar blending technique is then used to blend the colours and hide the dust. The results using Digital ICE and FARE are spectacular and will save hours of retouching work. The downside is that scanning times are significantly increased.

7/ This transparency had been stored for a number of years in a carousel slide tray. Even though great care was taken with the slide, dust still found its way in. To retouch this image would take hours, but by using an Epson 4870 flatbed scanner with Digital ICE turned on – scanning took about seven minutes and removed 98% of the dust and scratches.

8/ A detail of the original 35mm Ektachrome file.

9/ The same section, this time using Digital ICE .

printers and printing

continuous tone. Some manufacturers also include light greys; these produce outstanding tones on monochrome images and will also give added depth to colour photographs. HP claims that using their No.59 grey cartridge will give the printer an extended palette of 72.9 million unique colours. Most printers can only create a palette of 17 unique shades of grey, the other grey shades are made up from a composite of the CMYK inks.

Ink drops are measured in Pico litres and there are

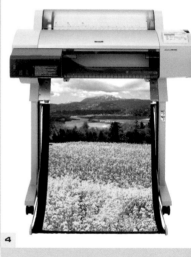

Taking a photograph and manipulating it is just the start of the creative process. For many photographers the important stage is producing the print itself. Choosing the right printer can be a daunting task, especially as there are several printer technologies available. Think of the printer as being the enlarger.

printers

The most popular and probably the most cost-effective printer is the inkjet. Inkjet printers are available in different sizes; A5, A4, A3, A3+, A2 and larger formats. An inkjet printer works by firing very small drops of ink at coated paper; the more droplets the printer can fire, the higher the resolution. Photographic-quality inkjet printers usually have six or more coloured ink cartridges, Cyan, Yellow, Magenta, Light Cyan, Light Magenta and Black – using more colours enables a printer to produce photographs of near

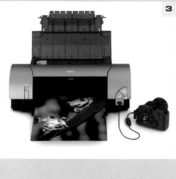

consumer printers which can produce ultra small 1 Pico Litre droplets. Each ink drop is about 1/10 the size of a human hair and smaller than a film grain particle. For optimum photographic quality, the ink drops need to be very small and placed close to each other. The larger the print size, the larger

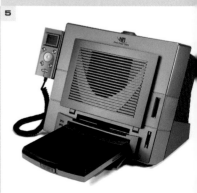

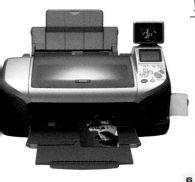

6

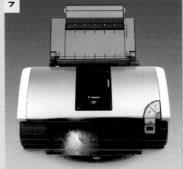

7

the drop can be.

There is an increase in popularity for Direct Print printers and most manufacturers have at least one or two models in their ranges. These printers incorporate memory card slots or offer a facility to connect a camera, in theory eliminating the need for a computer. For the photographer shooting on location it is the ideal tool for proof printing. For more serious work, a computer with quality Imaging software is still essential. To avoid multiple memory card slots many manufacturers are now adopting PictBridge. A PictBridge compatible camera is linked directly to the printer and the printer settings are controlled from the LCD screen on the camera.

The next printer type is the thermal or dye-sublimation printer. This uses three coloured ink ribbons; Cyan, Magenta and Yellow. The dye on the ribbons is heated and vaporises into a gas which is deposited onto the media to create the photograph. The paper is fed through the printer four times, on each pass it picks up another colour and on the last, a clear coating. The quality of reproduction is very high, but

as the printer uses a combination of the three ribbons to create a composite black, the photograph can appear to lack dynamic quality. Dye-sub printers are available in A4 or 6 x 4inch sizes and the smaller prints can work out cheaper than inkjet prints. A4 dye-sub printers are both expensive to buy and run.

Colour laser printers work in a similar way to photocopiers; they use a toner and are not suitable for high-quality photographic output. However, they are good for proofing, letterhead stationary and other day-to-day printing needs.

inks

There are two types of inkjet printers; dye ink and pigment ink. Dye ink printers are the most common, these are quick drying and produce outstanding colours with high gloss media. Dye prints are an excellent choice for exhibition and display work where the photographer may want to create impact. The downside of dye ink is that it is not as lightfast as pigment inks. Dye ink prints have a lifespan of between 10 and 25 years.

Pigment inks are better suited for long print life, having a lifespan between 75 and 100 years. The downside is that pigment ink prints don't have the same image impact as a dye print, although they are capable of reproducing soft and subtle tones. This makes them ideal for portrait photography and fine art prints.

8 ink status monitor

9 print control

1/ Photograph by Hans Claesson from Sweden. The Epson 2100/2200 pigment printer will print many subtle shades of grey and is a good choice for portraiture.

2/ The Epson 2100 A3 printer uses UltraChrome pigment inks and is an ideal choice for photographers selling their work

3/ This is an eight ink A3 printer made by Canon that offers PictBridge and can also print directly onto coated CD/DVDs.

4/ This Epson is a large format printer that uses UltraChrome pigment inks and will print on roll and flat media up to 24inch wide. This printer is particularly well-suited to the professional studio or creative photographer who sells limited edition prints.

5/ HiTi offer a range of dye sublimation printers that cover sizes from 6 x 4inch to 8 x 6inch. This printer, the 630PS, will produce economically priced 6 x 4inch prints.

6/ This Epson Direct Print printer has memory card slots and does not need a computer to produce prints. Direct Print printers are gaining in popularity and are an ideal proofing tool for the professional photographer.

7/ This Canon is an A4 printer that uses six separate ink cartridges so you only need to replace the depleted ink. The Canon printers are probably the fastest available

8/ A warning will be given when your inks are running low

9/ Most printers offer a degree of colour control, it is better to correct colours in an imaging application or use a good profile.

1/ 2/ 3/ 4/ A printer with a different Pico litre drop size was used for each of the four samples. The 2pl and 3pl pictures are the sharpest and smoothest toned prints, whereas the 4pl and 5pl show the print dot. The enlargements are extreme and under normal viewing conditions you would not see the print dot as it is smaller than the film grain.

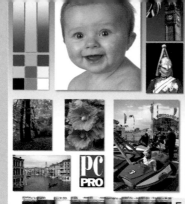

5/ Create your own test file using a variety of colours and subject matter. You can use this to test new media or printers. I created this reference print for a UK magazine and use it on all my printer reviews.

6/ A monochrome print without colour cast.

7/ The same monochrome print with a colour cast created by using a combination of colours to produce a grey.

! Some manufactures achieve greater colour saturation by firing more ink at the media, others may use their ink conservatively. Matching the media to the ink avoids ink pooling on the paper surface (puddles of ink).

5

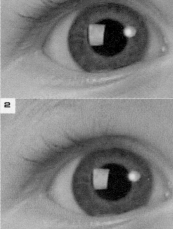

1

2

3

4

fading

One of the biggest problems facing photographers is the life of an inkjet print. Manufacturers may claim a lifespan of 10–25 years for dye-based inkjet prints; this assumes the prints will be displayed or stored in ideal conditions, i.e. behind glass or in a dark box. In reality very few prints make it past two to five years in an everyday environment and some prints can start to show signs of fading much sooner. Pigment ink prints will last considerably longer, up to 75 years or more. This exceeds the print life of a conventional wet-chemistry print.

There are two types of fading, light fade and gas or air fade. Light fade is caused by light bleaching out the colours in the same way that material will fade over time. Generally speaking all colours will fade with time. There is little you can do about this unless you keep the prints in a dimly-lit room or dark draw – which defeats the purpose of having a picture.

The other type of fading is the most common – air or gas fade. This is caused by atmospheric gasses. The gas mixes with the ink dyes and gradually eats away at the colours.

6

7

! If you are intending to sell your prints then make sure the ink/media life is not going to fade. Pigment inks will give the longest life.

The key to long print life is the media and inks being used. Photographic quality paper is more than just a sheet of white paper with a high gloss finish. Some premium papers have six or more coatings to produce optimum photographic quality. The coatings are designed to absorb the ink dyes fast, offer protection against abrasions and a brilliant white paper base. This is why key manufacturer's papers are more expensive than the bargain bin larger packs.

There are two types of paper coatings, porous and swellable. Porous media absorbs the inks almost instantly and the prints are dry to touch within seconds. They will also have a higher gloss finish and produce spectacular-looking prints with bold colours. The downside of this media is that the ink is sucked into the microscopic pores together with any atmospheric pollutants, which will gradually eat away at the dyes. Also the porous media continues to let pollutants in throughout its life.

Swellable media is a coating that swells as soon as ink hits it. The ink embeds itself into the coating and the swellable polymer encapsulates the dyes to provide a seal against the atmospheric pollutants. The downside with this is that prints can take several minutes before they are dry to touch and ideally they should be left untouched for 24 hours or more (one manufacturer even recommends leaving the print for seven days). Photographs printed on swellable media will have a much longer life (aproximately 75 years) than those printed on porous media.

Epson has several printers that use pigment-based UltraChrome inks. The pigment ink drops are encapsulated in a micro-coating of resin that helps to prevent any air pollutant damage. The net result is that the prints will last five times longer than a conventional photograph. Generally pigment inks will not work well on glossy media due to the fact it sits on the surface of the paper.

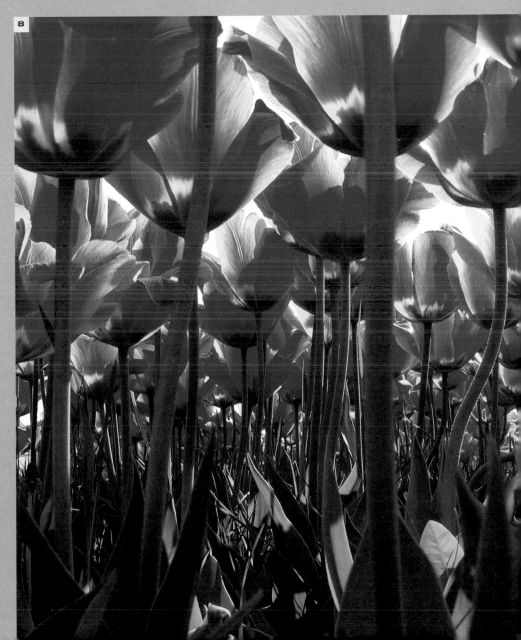

8/ Photograph by Willem Dijkstra. Some colours have more impact than others when printed. These tulips appear to jump off the page when printed on a dye ink printer.

2 management

'Untitled' by Heather McFarland.

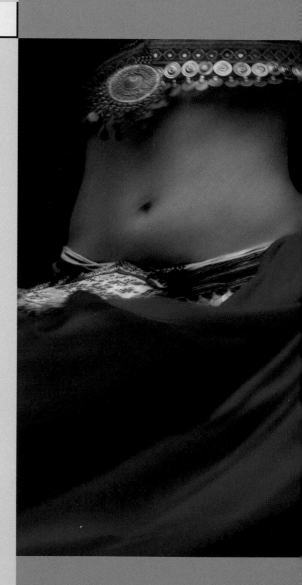

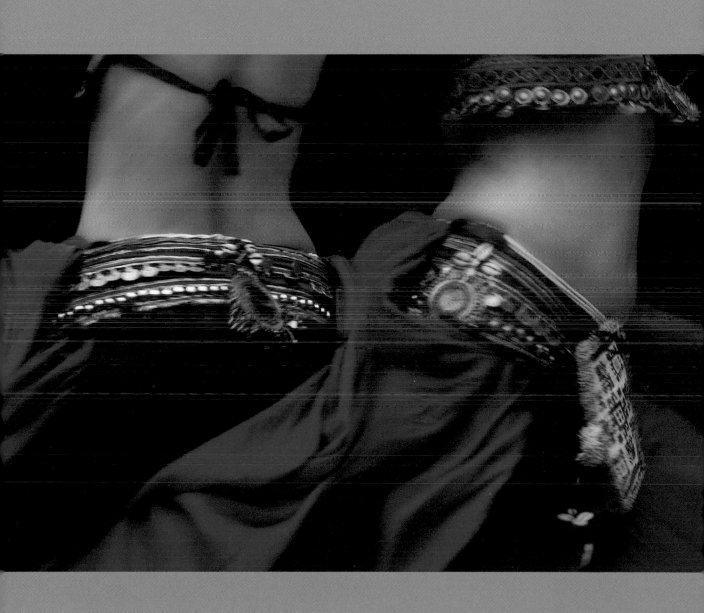

! Make a duplicate copy of your image folder before applying profiles to a batch of pictures – just in case it doesn't work out the way you expect it to.

colour management

1

Not so very long ago colour printing was the domain of the expert. Very few photographers explored printing colour to the same degree as monochrome. This was, and still is, mainly due to the complicated filtering and precise temperatures that are required for producing a print.
Today even the absolute beginner in digital photography can produce superb colour results.
For the photographer who is willing to take time to learn the ins and outs of colour management and profiling, the rewards are even greater.

One of the major problems for most users is matching their prints to what they see on the monitor. The screen looks great, but the print may be washed out, too dark or the wrong colour. What do you do? Do you adjust the monitor to match your print or do you adjust your print to match the monitor? It would be far simpler if your printer knew how the picture was being displayed and could produce the same colour. With colour management, it can.

Here is a simple example to explain the concept of colour management. If four singers independently recorded an unaccompanied song and then the four recordings were combined, there would no doubt be a variation in pitch and tempo and the recording probably wouldn't be worth listening to. Now if each of the singers was given a reference note (pitch)

and a tempo then the recording would stand a better chance of working. Apply the first scenario to digital pictures and instead of singers substitute a monitor, scanner, camera, and printer – you would probably get a similar hit or miss result. Now if the hardware items were calibrated and profiles applied, a reference point will have then been established and the end results should be more accurate.
This, in a nutshell, is what colour management is all about.

Each item; monitor, scanner, camera and printer has its own colour gamut. For example, a typical monitor displays more colours than a printer can print. Unless each item knows how the other is going to perform, then the colours can be all over the place. Fortunately, most manufacturers supply 'canned' profiles with their hardware. These are installed automatically

with the drivers during the installation process. The supplied profiles usually conform to the ICC (International Colour Consortium) format and should be more than sufficient to give quality results. However, for custom and more accurate results you should consider investing in a hardware/software profiling application.

monitor calibration

When you are in an electrical appliances store, have a look at the TV department and observe the variation in colour from one TV set to another. If you placed several monitors side by side you would see a similar variation, even on models from the same manufacturer (1).

Fortunately, with the right equipment, calibrating a monitor is an easy process. In our shot, each of the monitors on its own looks acceptable, because the differences are subtle. Rather than select a personal favourite, it is better practice to calibrate the monitor to a known

reference point so that absolute accuracy is guaranteed.

visual calibration

Adobe Gamma (2) is the most popular application for monitor calibration. This is installed with Photoshop and can be found in the Control Panel (Start > Control Panel). There are two modes; as a step-by-step Wizard or as a Control Panel. The first option takes you step-by-step through the entire process, whereas the Control Panel leaves you to make all the adjustments. Adobe Gamma will produce a reasonable profile of your monitor, but as this relies on your own perception of what is being displayed, it's not going to be as accurate as a hardware calibration.

! Allow your monitor to warm up for at least 30 minutes before making any critical colour adjustments to a picture.

! For high colour accuracy use a CRT monitor, LCD screens are not as good unless you are prepared to invest in a top-of-the-range screen.

hardware calibration

Another method is to calibrate the monitor with a hardware device called a colorimeter (or spyder) which attaches to the monitor screen via a rubber suction cup. There are two versions of the meter, one for CRT (4) and the other for LCD screens (3). Do not use the CRT version on a LCD screen, the pressure required to attach it will damage the screen. Once the meter is in place, the profiling software will generate a series of colour patches. The meter measures the values of these and compares them to a reference file, thereby creating a profile of the monitor. This produces a very accurate profile of your monitor as the meter is not influenced by ambient light or personal preferences. For serious imaging work a colorimeter should be a high priority purchase.

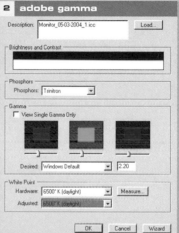

2 adobe gamma

1/ Monitor variations.
2/ Adobe Gamma adjustment.
3/ Spyder for LCD screens.
4/ Spyder for CRT.

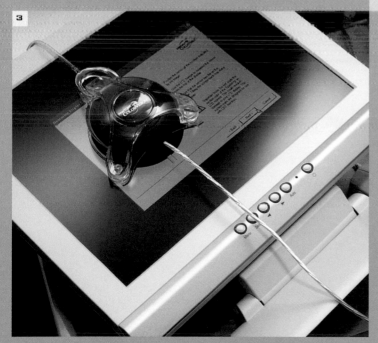

3

4 spyder

! It can be difficult to get a colorimeter to sit absolutely flat on a LCD display. Try laying the screen down and carefully placing the meter on the screen like that.

scanner calibration

Most scanners have an automatic setting, which for 80–90 percent of all pictures will produce a good result. Occasionally images with a heavy bias of colour can fool the scanner into thinking there is a colour cast present and it will correct the cast with disastrous results. A better way to use a scanner (film or reflective) is to profile the unit and then scan the photograph without any adjustments applied. The result will no doubt look awful, but if you have profiled the scanner correctly then applying your custom profile will correct the colours to produce a perfect result.

To calibrate a scanner you will need an IT8 target and a reference file. Scan the target, print or transparency, without any colour adjustment, and the profiling software will ask for a reference file, browse to the folder that contains this. Each IT8 target has its own unique reference file (be careful not to use another manufacturer's file). The software compares each colour patch to the reference file and compensates where the measured value doesn't match the reference value. The profile it creates contains the shifts in colour required to correct the colours, and this is saved into your profiles folder.

To apply a profile, scan in an image with the 'No colour' adjustment setting. In Photoshop select Mode > Apply profile, enter the profile name and press OK. The image is now corrected with the profile you have created. As a last step you must convert the scan back to the colour space you are working in (for professional work this may be Adobe 1998, for web work probably sRGB); go to Mode > Convert profile and select the space you are working in.

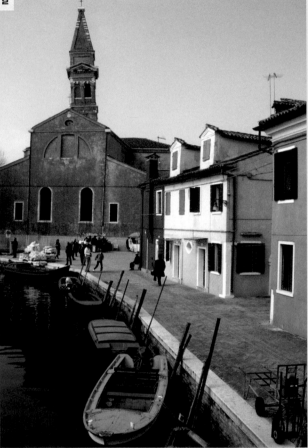

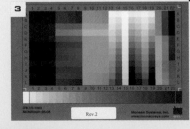

1/ Scanned with no profile.

2/ Scanned with profile.
3/ An IT8 calibration card.

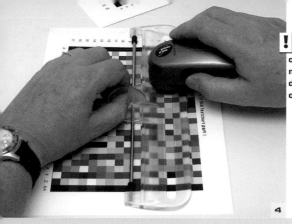

4

printer calibration

Buying a printer and using the manufacturer's own brand or recommended media should produce more than acceptable results. Deviate from this and use another paper or ink combination and the supplied profiles may give you less than desirable results. The answer is to create a custom profile for the media you intend to use that takes into account how the ink reacts with the paper.

Creating a profile for a printer and paper combination requires a hardware solution. At the simplest level you can print out a reference file and scan this, then measure the scan of the IT8 target against a reference file and make adjustments (4). For more accurate results a custom set of colour patches are printed and these are read using a spectrophotometer; each patch is read, then compared to the reference file and a set of adjustments is stored. When you print using your custom profile the adjustments are applied and the result will be an accurate rendition of your image. That's the theory. In practice you will always have to make an adjustment to compensate for slight deviations in subject matter, i.e. if you shot a model in slightly cool light you may want to increase the yellow and red to give a more pleasing result.

5

digital camera calibration

At the simplest level, a camera can be used to create a white balance of any situation, this will guarantee that no unwanted colour casts are inherent within a particular sequence of pictures. The easiest way is to photograph a white sheet of paper and most advanced digital cameras will create a white balance for the scene. This will eliminate most colour casts within a picture. The alternative is to create a colour profile for the digital camera using the same technique as with the scanner (5/6). A large IT8 target is available, or a Gretag Macbeth colour chart. Take a picture of the target and run the digital file through the profiling software. This works well in controlled lighting conditions such as a studio, but will not work very well on location, due to the diverse lighting conditions. However, you could start any session by photographing the colour chart and then creating a unique profile for that particular session. The profile can be applied by a batch command to the entire session.

6

4/ Using a spectrophotometer.

5/ 6/ Before and after setting a session white balance on a digital camera.

Most digital cameras are supplied with some form of image management software. These are generally basic applications for quickly transferring images from camera to computer, or for viewing folder contents. Their use is usually limited, but may include a simple image database for a quick search. Advanced users should consider a dedicated asset management application such as Extensis Portfolio 6, ACDSee 6 or FotoStation Pro 5. These applications offer greater versatility in managing and cataloguing assets. The computer does not know that file DSC_3456 is your prize-winning picture of Venice. You will have to add keywords – those descriptive words or phrases that enable you to refine a search to a more specific value.

managing digital assets

There is no doubt that when using a digital camera you are going to take more pictures than you would using film. Keeping track of digital files may seem daunting, especially with their meaningless names, such as **DSC_4576, IMG_3652, P1010034** etc. In computer jargon, files are called assets, and these could be **JPEGs, TIFFs, movie clips or text documents,** in fact almost any data file. By using a good asset management software application you should be able to search through thousands of files in a matter of seconds to find the right file.

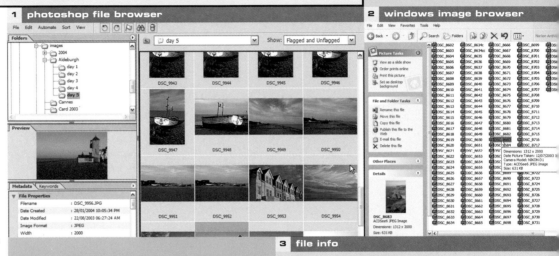

1 photoshop file browser

2 windows image browser

3 file info

1/ Photoshop has its own File Browser, this is useful, but not that sophisticated for complicated searches.

2/ With the Windows image browser you can view images in several ways, including as a list, or in Slideshow mode.

3/ In Photoshop, information can be added to any image via the menu – File Info or Alt + Ctrl + I. This file information conforms to the industry standard International Press Telecommunications Council (IPTC) and can be used by a number of asset management applications for performing a search. Many applications have their own keyword system but if you are intending to send out your pictures to stock libraries, or for publication, then staying compatible with the industry standard should be a high priority.

4 categories

Categories

- Holiday brochure
- Landscapes
- Portraits
- Botany
- ⊞ Weddings 2004
- ⊞ Weddings 2003
- ⊟ Magazine submissions
 - Radio Times
 - What's on TV
 - TV Times
 - Woman's Own

New... Remove... Delete...

4/ Once images have been catalogued then you can create Categories, Albums, or Jobs. These enable you to keep track of work-in-progress and images required for specific projects. To add images to a project you simply drag and drop the picture on to the job folder. This won't move the picture from its original location, it just adds a thumbnail or shortcut link to the file.

5/ Extensis Portfolio is regarded as an industry standard and offers many features including a very sophisticated keywording facility. A separate window can be created for new Catalogues and Categories, pictures can be moved from one Catalogue to another, or the collection of pictures saved to another folder. Folders or even entire drives can be watched. If you add more pictures to a folder these will be automatically added to your database. Pressing Ctrl + E opens the selected file in your chosen application.

! Your Operating System (OS) has a limited facility to browse for pictures and this is far from ideal for large collections of images. Invest in a professional asset management application and it will pay for itself in no time.

! Create image folders with their own unique names so you can quickly locate sets of pictures.

5 extensis portfolio

! The EXIF information of a digital image may be lost if you rename the file. Check that your renumbering system doesn't destroy this useful information.

6/ ACDSee 6 is a popular image management application for Windows. Folders of images can be quickly viewed as thumbnails or as an instant slideshow. Highlight a picture, press Ctrl + E, and the photograph will be opened in your image-editing application. A fast and easy-to-use browser.

! Most digital asset management applications have a rotate feature. Make sure it is a 'lossless' rotation otherwise you will loose quality on your JPEGs.

6 ACDSee 6

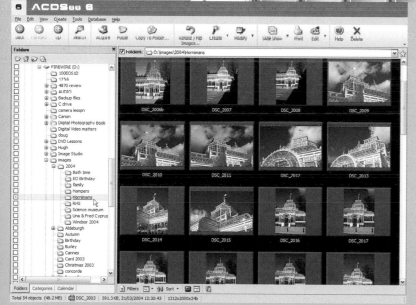

! Create regular back-ups of your image database – they take a long time to compile and even longer to re-write.

! Adding keywords to your images may take time but it is vital if you want to perform a quick search.

! Hard disks are the fastest way to access your pictures, but for long-term storage consider other media types such as **DVD, CD** and **Optical** drives.

essential software

Choosing a good software package is not that hard. Adobe Photoshop is generally regarded as the de-facto standard for image manipulation. This enviable position has been secured through a robust application with tools that are both intuitive and useful to the photographer. There are numerous books devoted to Photoshop, as well as CD tutorial courses, magazines and educational institutes. Photoshop is available for both Windows and Macintosh computer platforms, and once in the application you can forget about the computer you're using as Photoshop will do the same job on either platform. The major difference between Mac and Windows is that Windows uses the Control key (Ctrl) whereas the Mac uses the Option or Apple key, otherwise operation is identical.

1

imaging

Although Photoshop reigns supreme in image manipulation, don't rule out some of the other and often cheaper applications. A photographer wouldn't use just one camera and one lens, they may use a variety of cameras and lenses according to what they want to achieve. The same holds true for image manipulation work. It's well worth investigating other applications as each has its own unique features. JASC Paint Shop Pro has an excellent

'Picture Tubes' brush, this enables you to spray small decorative images on to a picture. Micrografx Picture Publisher has such an excellent lens flare filter, that Photoshop's pales in comparison. Corel's Photo Paint has some interesting filters, including a cut-down version of the superb Paint Alchemy filter. It can be cheaper to purchase another imaging application just for a couple of its bundled filters, rather than buying a similar

plug-in for Photoshop. As a bonus, most imaging applications conform to the Adobe plug-in standard and will also open Photoshop's own PSD file format. This keeps the Layers intact, making it easier to work on an image using multiple applications.

utility applications

There is no doubt that the internet has many useful resources. You may want to download software updates, browse for picture ideas from other websites or simply send and receive emails. It is not unreasonable to want to do any of these activities, but the danger with the internet is that you can leave your computer open to a virus attack. There are thousands of viruses waiting to pounce and these can corrupt or destroy valuable files or even scan your

hard drive for your credit card information. The best cure for this is prevention.

There are several anti-virus applications available. The leading packages are Norton's and McAfee, both of these will scan files as you surf through the internet. They will also scan disks that have been sent by friends or clients, and any viruses that have been (unintentionally) included will be stopped. The downside using virus protection is that it can slow your system down. You must keep

your anti-virus software up to date, as new viruses are discovered almost on a daily basis. Norton's has a small application called Live Update; this runs itself every time you log on to the internet and will automatically download the latest virus protection.

3 norton antivirus

1/ Photograph by Vincent Oliver.

2/ Norton's anti-virus software application Live Update runs automatically, searching for new downloads to combat new viruses.

3/ Norton's system status screen.

spying

Anti-virus software is not always a guarantee that your computer won't be hacked. You can also fall victim to spying software. This is not a virus, but it can monitor every key stroke you make or report back about the types of site you have visited. This can result in your credit card numbers being available to others or inundated with spams. A small application called Ad-Aware is a freeware application from www.lavasoft.de which will seek out and remove any offending items. Typically I find at least five intrusions every time I use the web. Some shareware applications also place items in your system to gather information.

Ad-aware 6 Personal, Build 6.181

4/ Ad-Aware, free from www.lavasoft.de finds and destroys spying software.

5/ SuperCat from http://no-nonsense-software.com/ adds quick listing facilities to remove media.

6/ WinZip collects and compresses files for sending as email attachments.

7/ 8/ 9/ PhotoRescue will recover deleted files.

catalogues

Creating catalogues of images is a necessity for locating files. The SuperCat application creates a quick listing of the folder and file names on a CD or other removable media. Put your media disk in the drive and press the Create catalogue button and the folders or files are instantly added to the catalogue. This is useful for quickly locating a folder or file without viewing the thumbnail images. Preview images are available for media that is loaded or for files on a local computer.

WinZip

This small inexpensive application will collect and compress files ready for sending as an email attachment. Many internet downloads and upgrades are supplied as self extracting WinZip files. JPEG and TIFF Photographs can also be added to any archive. Visit www.winzip.com for further information.

6 winzip

File Actions Options Help

New | Open | Favorites | Add | Extract | Encrypt | View | CheckOut | Wizard

Name ▲	Type	Modified	Size	Ratio	Packed	Path
DSC_1997.jpg	JPEG Image	17/03/2004 14:35	1,150,946	4%	1,104,...	
Easter2.doc	Microsoft W...	18/03/2004 10:38	32,256	81%	6,005	
end.jpg	JPEG Image	18/03/2004 09:48	2,077,771	1%	2,059,...	
invite.jpg	JPEG Image	18/03/2004 10:37	1,615,696	0%	1,611,...	
Start.jpg	JPEG Image	17/03/2004 13:21	1,680,604	2%	1,643,...	
tubes_000.tif	TIF Image	17/03/2004 19:14	1,646,058	51%	812,177	
tubes_001.tif	TIF Image	17/03/2004 19:18	1,922,788	61%	751,093	
tubes_002.tif	TIF Image	17/03/2004 19:30	2,476,903	79%	522,593	
tubes_003.tif	TIF Image	17/03/2004 19:31	617,361	83%	104,027	
tubes_004.tif	TIF Image	17/03/2004 19:43	925,908	67%	304,204	
tubes_005.tif	TIF Image	17/03/2004 19:54	258,612	54%	119,764	
tubes_006.tif	TIF Image	17/03/2004 19:57	258,612	72%	71,744	
tubes_007.tif	TIF Image	17/03/2004 20:08	728,404	90%	70,076	
tubes_008.tif	TIF Image	17/03/2004 20:16	2,476,903	92%	189,901	
tubes_010.tif	TIF Image	17/03/2004 20:30	2,476,903	85%	363,338	
tubes_011.tif	TIF Image	17/03/2004 20:35	536,352	96%	24,124	
tubes_013.tif	TIF Image	17/03/2004 20:39	2,476,903	81%	387,102	
tubes_014.tif	TIF Image	17/03/2004 20:42	457,188	97%	14,209	
tubes_015.tif	TIF Image	17/03/2004 20:57	2,476,903	87%	326,602	

Selected 0 files, 0 bytes Total 19 files, 25,677KB

data loss

One problem you may encounter is accidentally formatting a memory card before you have downloaded the pictures. Like when you lock your keys in the car, you instinctively know you've done it just as you slam your door. The same holds true for formatting a memory card, you know it's too late as soon as you press the OK button. Fortunately there is software that will recover your files. PhotoRescue by DataRescue is an inexpensive application that will pay for itself the first time you use it. It does an amazing job of recovering files that were deleted weeks ago, although by using your card again after formatting you may not be able to recover all the files. It will also find deleted files from your hard drive and other removable media. Find PhotoRescue at www.datarescue.com.

7 photo drive

Please specify the photo drive:
Input type
- ⦿ Logical drive
- ○ Physical drive
- ○ File

☑ Determine the card size
☑ Cache the input
☐ Expert mode

[◄━ I ▼]

OK Cancel

8 logical drive

Analysis
Reading sector	39,927
Directories found	4
Files found	15
Crippled files	
Contiguous files	
Recovered size	13,803,520

Totals
Total sectors	62,560
Total clusters	15,601
Cluster size	2,048
FAT	16
Root directory size	512
Total size	32,030,720

Recovery method 4...

Cancel

Analyzing Logical Drive I:...
1. Determining the input structure, please wait...
2. Reading existing files...
3. Recovering files using FAT...
4. Recovering directories...

9 logical drive

File Edit Help

FOUND

V0020097.JPG V0020098.JPG V0020099.JPG

V0020100.JPG V0020101.JPG V0020102.JPG

V0020103.JPG V0020104.JPG V0020105.JPG

3 manipulating & retouching

'Seagulls' by Ben Goossens

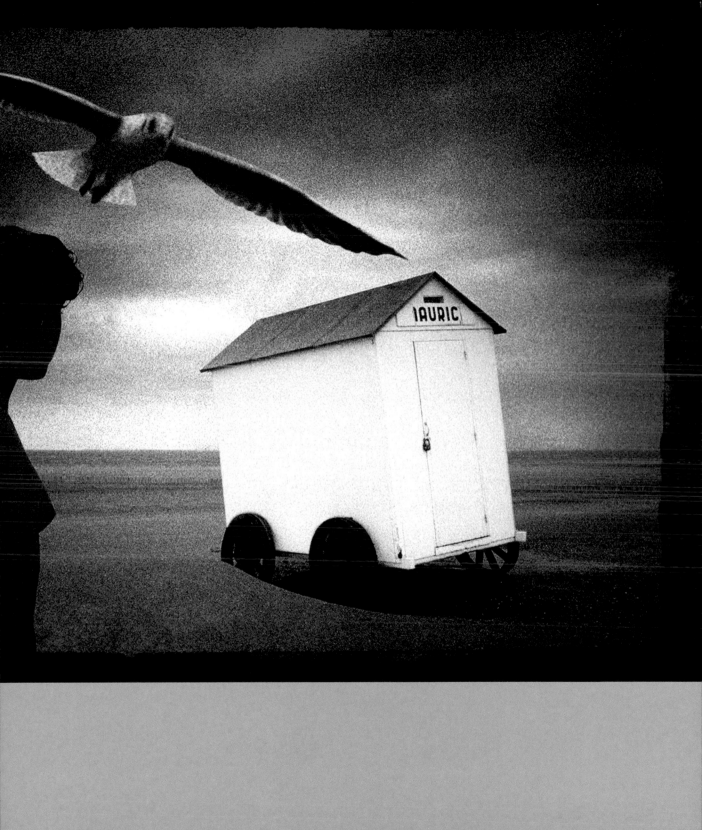

1

! A graphics tablet is an essential item for any digital photographer. Although expensive they will make retouching work easier.

! A large 19inch or 21inch colour-corrected monitor using a screen resolution of 1024 x 768 pixels or larger is the minimum requirement. 15inch and 17inch screens are too small.

retouching images

One of the main advantages of digital imaging is the fact that you can alter or correct any element within a picture. Pictures that previously may have been consigned to the bin are now salvageable. Retouching has been possible with film and prints, but advanced work was left to the expert and often costly specialist. There are many software packages available ranging in price from free (shareware), to a few pounds, to several hundreds; but without doubt the software every photographer aspires to is, Adobe Photoshop. The learning curve is steep but the rewards are great.

photosloppers

The only area for concern with digital photography is that photographers can let their standards drop and enter a phase of sloppy photographic skills, with a view to correcting the faults in Photoshop. Of course the possibilities are there, but alterations and corrections take time and unless they are expertly done they can also give the wrong emphasis to a picture. Digital photography requires the same attention to detail and discipline as film – photographers should strive to maintain the highest standards regardless of the media being used.

retouching

There are going to be occasions where things are beyond your control – photographing a jaw dropping landscape and a white van parks in the centre of the frame, or your model turns up for a photo shoot with a rash on his face. Fortunately, both of these scenarios are relatively easy to correct, but make sure you use the right tool.

graphics tablets

A graphics tablet is essential for any serious retouching work, especially those tablets that have pressure sensitive areas. The benefit of being able to use a soft or hard brush stoke will be quickly realised once you start painting. A very soft hint of colour can be applied with a gentle stroke and you can deliver all the colour you want to using a harder stroke. There are several tablet sizes from A3 down to A6, so which should you choose?

The A3 size is far too big for photographic retouching, unless you like to exercise your drawing arm. This size is intended for graphic artists; a clear overlay on the tablet is intended for tracing work and artwork is placed under the overlay. The A4 tablet is probably as big as you need, but it will occupy a large amount of desk space. The A5 tablet is the ideal size for photo retouching, the accuracy offered by this size is every bit as good as its big counterparts. The A6 tablet is perfect for holding in your hand rather like a sketch book. There are several pen options, these are for airbrushing, calligraphy etc. but in my experience the standard pen supplied with the tablet is more than sufficient.

1/ 2/ 3/ Avoid re-cloning areas, a repeated pattern is a giveaway to retouching work (2). Use the eye dropper to frequently resample areas with a similar colour or pattern. Hold down the Alt key to pick up another area. Use a slightly harder brush otherwise the cloned area can start to look out of focus. When there are missing areas of detail such as the wall, then you have to use an amount of artistic licence and add bits that may not have been in the actual scene (3). Here the plant tub was repeated to cover up a difficult area.

4/ 5/ View your image at less than 100% and you may lose vital image information. Always retouch at 100% unless you are doing overall colour corrections.

4

5

2

3

> **!** **Before starting any retouching save your image under a new name. The original image file will then not be overwritten – useful if things don't go to plan.**

6

photoshop tools

One of the most powerful and indispensable tools in any imaging application is the Rubber Stamp or Clone tool. Many people who see this tool in action for the first time are amazed at what it can do, as if by magic one part of a picture is painted into another area. The actual concept of the tool is very simple, take a clump of pixels, copy them and then paste them to another part of the image – it's no more complicated than copying a few words on a word processor and pasting them into another sentence. The clever bit is that this is a continuous process, pixels are copied and pasted in real time and this gives the impression that the brush is re-painting the scene.

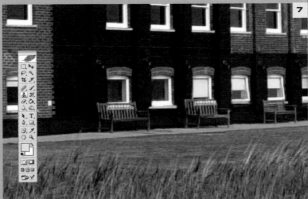

7

6/ 7/ In this part of the image there are plenty of similar elements (windows) to use for covering over the people. Use a variety of brush sizes for more precise cloning, pressing the square brackets on the keyboard will quickly resize the brush.

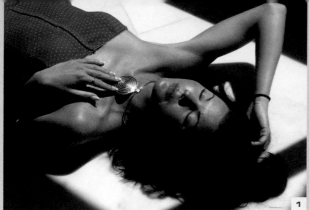

1/ 2/ 3/ Original and Retouched – Use the selection tool to copy a similar area when you have a large area that needs replacing. Copy the selected area and paste as a new Layer, move the Layer into the correct position and tidy up the edges with the clone tool or eraser. On the shot of the model the front zip was removed by copying an area of dress and then pasting it on top of the zip. The pattern was relatively easy to tidy up, a simple case of cloning single dots and making sure they followed the lines of the others.

! Hold down the space bar and the current tool will temporarily change into the hand tool. Drag the image to the next section and release the space bar to continue using the same tool.

keystrokes

Some photographers like to work with two monitors, one displays the picture whilst the other displays the palettes and tools. There is no need to clutter your desk with extra hardware when you can achieve the same with one monitor. Photoshop has shortcut keystrokes for just about every tool and adjustment. Once you know these then you can turn off all the tools, maximise the image window and retouch by using shortcut keys without even seeing the tool in use. Press the letter F twice to enter Full Screen Mode and then press the Tab key to hide all the palettes. Now press the letter S to use the Rubber Stamp tool, or Ctrl + M to open the Curves palette etc. A full list of the shortcut keystrokes can be found in the Help menu.

missing lines

For removing dust spots from scanned images, enlarge the image to 100% (double click on the zoom tool) and turn on the grid (Menu – View > Show > Grid). Depending on the image size, you may only see a portion on the screen. It is essential that you work at 100% or more so that you see all the image information. Displaying the full picture at 66.7% may mean some of the pixels will be missing. The grid will assist you in working your way through the image. Work on one grid square at a time and clean up that area before moving onto the next square. This method guarantees that you will not miss anything.

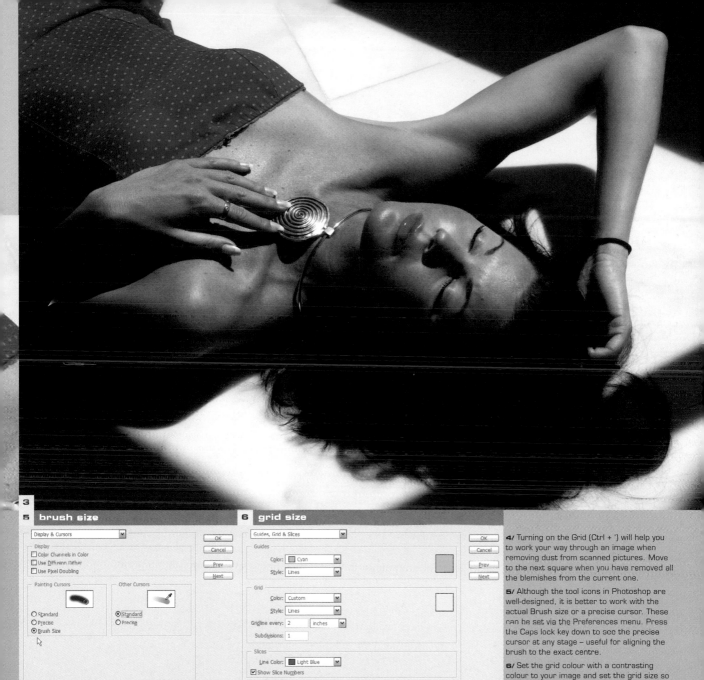

3

5 brush size

6 grid size

4/ Turning on the Grid (Ctrl + ') will help you to work your way through an image when removing dust from scanned pictures. Move to the next square when you have removed all the blemishes from the current one.

5/ Although the tool icons in Photoshop are well-designed, it is better to work with the actual Brush size or a precise cursor. These can be set via the Preferences menu. Press the Caps lock key down to see the precise cursor at any stage – useful for aligning the brush to the exact centre.

6/ Set the grid colour with a contrasting colour to your image and set the grid size so you are working with a 5–10cm square. The values can be set via Edit > Preferences > Guides, Grids and Slices.

! Photoshop has many shortcut keystrokes, learn them and your workflow will benefit from an increase in speed.

! For common tasks such as resizing, define an action. The sequence of instructions you define will be played back with a single keystroke.

! When using Levels, press the Auto button first, it may just fix the problem instantly. If not, then it will have brought the sliders in each of the Channels to the start of the histogram curve.

! Make sure your monitor is calibrated correctly and let it warm up for about 30 minutes before doing any critical colour corrections.

colour corrections

Colour is subjective, we each interpret colour differently and we also have our own preferences on how a colour should be rendered. A red rose could be acceptable to one person and totally unacceptable to another. However, we all know what a skin tone should look like and we try to get as close as possible to the reality. For other colours such as corporate logos etc. we can be more accurate and use known reference colours such as Pantone, Trumatch, Toyo etc. These colour sets are important for designers but for the greater part photographers can forget about them.

variations

There are several ways to correct colours using Photoshop or other imaging application. The simplest method is to use the Variations filter (1). This presents the user with 12 preview images, the top left

picture is the original file and the others are variations on it. Click on any picture to apply the colour or tone shift to the Current Pick, if it is going horrendously wrong, just click the Original preview and

everything is reset. The variations filter is basic and is sufficient for a quick adjustment, but for more accurate control you will have to look elsewhere.

1 variations filter

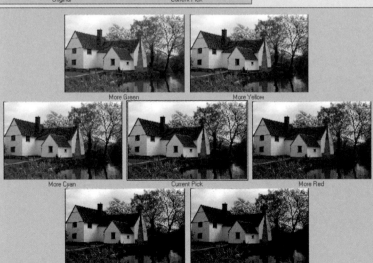

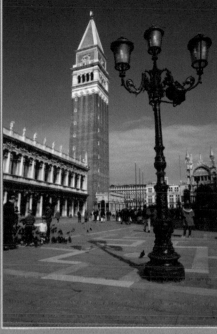

1/ The variations filter.

2/ Curves correction.

3/ Selecting the point option.

4/ Setting the values of the B/W clipping points.

5/ 'Colours' by Ilona Wellmann. This colourful photograph of a parrot's feathers was intensified using Nik Color EfexPro, this gave Ilona an increase in colour saturation. A similar result can be achieved by increasing the overall saturation in Photoshop (Ctrl + U). Use the drop down list to selectively increase the saturation on the various colours.

to plan you can reset the curve by holding down the Alt key and the Cancel button changes to a Reset button.

Grey areas in a picture will quickly show up any unwanted colour cast, magenta is the offending cast in picture (3). Curves (Ctrl + M) was selected and the centre Grey Point option (eyedropper) was used to take a sample of the grey pavement. This automatically shifts the colours into their correct space. Clicking on the options button gives further choices including setting the values of the black and white clipping points (4).

If you are working on a series of pictures then you can save your curve setting and reload it on the next image. Alternatively if you press Ctrl + Alt + M, then the Curves will be launched and the last used settings will be applied.

curves

Generally we use Curves to make tonal adjustments to an image and to lighten or darken areas. Curves is a versatile tool as you can also use it to colour correct an image; from the drop-down list select the colour you want to alter and drag a point on the curve to make an alteration (2). If your curves Adjustment hasn't gone

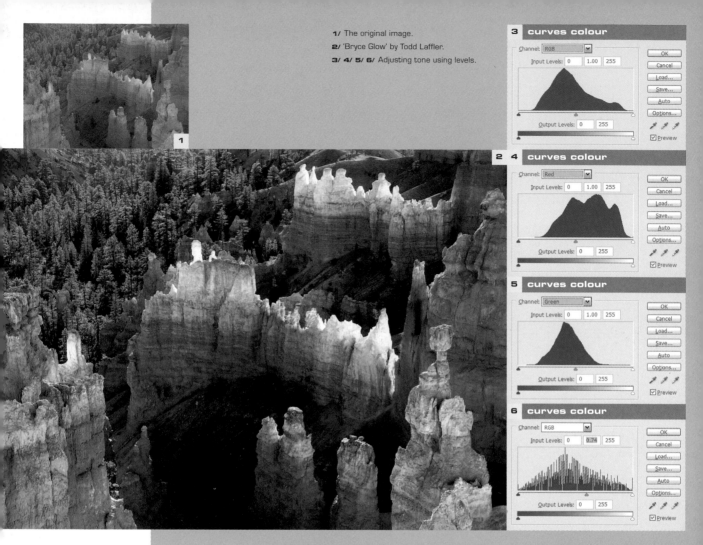

1/ The original image.
2/ 'Bryce Glow' by Todd Laffler.
3/ 4/ 5/ 6/ Adjusting tone using levels.

3 curves colour

Channel: RGB

Input Levels: 0 1.00 255

OK
Cancel
Load...
Save...
Auto
Options...

Output Levels: 0 255

☑ Preview

2 **4** curves colour

Channel: Red

Input Levels: 0 1.00 255

OK
Cancel
Load...
Save...
Auto
Options...

Output Levels: 0 255

☑ Preview

5 curves colour

Channel: Green

Input Levels: 0 1.00 255

OK
Cancel
Load...
Save...
Auto
Options...

Output Levels: 0 255

☑ Preview

6 curves colour

Channel: RGB

Input Levels: 0 0.74 255

OK
Cancel
Load...
Save...
Auto
Options...

Output Levels: 0 255

☑ Preview

levels

Many photographers prefer to use Levels for tone correction. The Levels dialog box displays a histogram of the current image. At either end there is a marker, Highlight (right) and Shadow (left), there is also a midpoint marker for the Mid-tones. Drag each of the sliders to alter the tones. Levels also has a drop-down list that has each of the colour channels. Select a channel and

move the sliders inwards and you will observe a shift in colour. To use Levels for correcting colours you have to go into each colour channel and move the outer sliders inwards until they meet the start of the curve. This has been done on the example shot and the original shot has been markedly improved [1/2]. Most images can be colour corrected in a few minutes using Levels.

Each channel has its own histogram, move the outer markers inwards to meet the start of the slope on each of the channels and any moderate colour cast will be removed. The final histogram (6) shows how the curve has been expanded, ideally this should be a continuous curve without gaps in it.

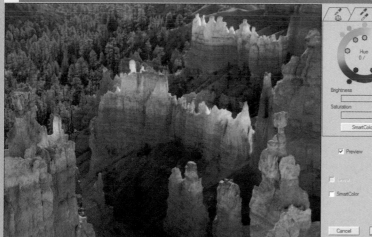

7/ Extensis Intellihance 4.1 is a variations-style application. It has many options for correcting tone, colours, sharpness, descreen, etc. The result can be applied directly to an image or as a new Layer. There is also an option to save the grid as a new Layer. This is handy for printing out a test sheet with all the permutations on it.

8/ There are several applications to assist in colour correction work. ICorrect EditLab will remove a colour cast and tweak the colours, you can save the settings as a colour profile.

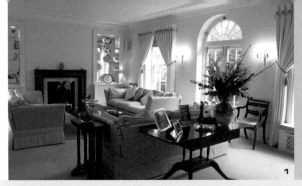

1

salvaging pictures

Not every photographic session goes to plan; problems on outdoor locations can often be beyond your immediate control, especially when shooting in a public place or due to uninspired weather. To brighten up a dull day photographers often resort to using the warming tones of the 81 series filters or they add interest to a sky by using a graduated filter.

white balance

With film cameras we have to use the correct film stock. If shooting an interior, tungsten film stock will be used rather than daylight balanced film. A similar set-up exists for digital cameras, the correct colour balance must be set for the shooting conditions. This is normally set by the Colour or White Balance setting. The camera can be set to Auto White Balance, but this is letting the camera decide what is the best colour for your needs and it can be well off the mark at times.

Setting a custom white balance is a quick job. Set your camera to create a custom white balance, point the camera at a sheet of white paper and take a picture. The correct white balance will now be set for the shooting conditions you are in. If the scene is lit by fluorescent lighting, then the camera will add magenta or another colour to bring back the white sheet to the correct colour. This custom white balance only takes a few minutes, so try to make a habit of doing it before every session, as it will save a lot of time trying to correct it later. However, if you forget, then no problem...

correct

On the first shot the camera's white balance was left set to tungsten from a previous shoot (1), fortunately in this case the mistake was spotted early in the session, but the first shots had to be corrected in Photoshop.

On the example picture, various tools were used to correct the blue cast (2/3/4/5/6).

Each method produced a reasonable result, but probably not as good as shooting with the correct setting in the first instance would have been. A combination of two or more Adjustment types helped to bring the image back to a level of acceptability (7).

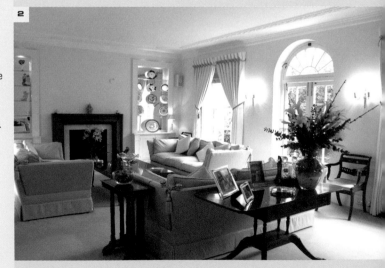

2

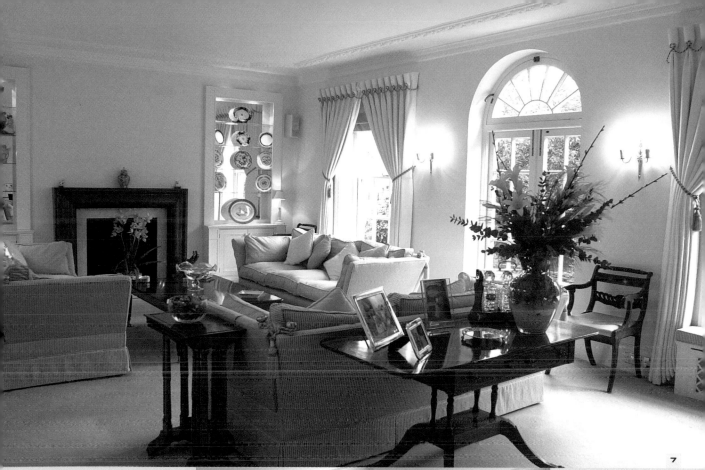

7

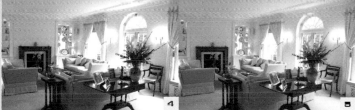

4

5

3

6

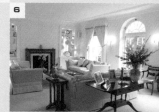

1/ Original capture with incorrect white balance setting.

2/ Correcting with levels.

3/ Correcting with Curves.

4/ Correcting with Colour Balance.

5/ Selective Colour.

6/ A plug-in filter from Pictographics called Correct Edit Lab.

7/ The final corrected image.

! **Check all the settings on a digital camera before you start. It's often the obvious settings that are overlooked – i.e. white balance.**

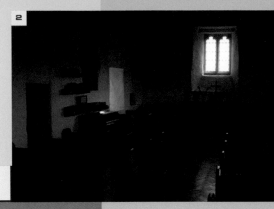

> **!** Use the histogram function on a digital camera to ensure that you have captured as much of the image information as possible.

> **!** Underexpose rather than overexpose. Take several shots of key elements, varying the exposure and then merge them together to form the final image.

salvaging pictures II

Photographers are renowned for carrying excess baggage; cameras, lights, tripods, bags etc. Digital photographers can add a laptop computer to this list. Laptops are great insurance for any shoot as images can be checked instantly on location. But having all the right gear isn't always a guarantee that things will run smoothly.

1 nikon D1

shoot anyway

A dimly-lit church in Wales was the assignment, and this church was in a remote area without any power. So even though we had a comprehensive set of lighting equipment with us, this was rendered redundant. Even when you're in a seemingly impossible situation there is little point in returning home without taking a picture. Take the pictures and see what can be done on a computer back at base. This is exactly what I did here (2). I took several shots varying the exposure. Digital cameras are quite forgiving, but as with film you mustn't overexpose. Burnt-out highlights are difficult, if not impossible, to recover.

raw mode

To avoid white balance problems, the best method is to shoot in RAW mode. This method doesn't apply any algorithms to an image, these are applied afterwards by the user. Both Canon and Nikon have their own dedicated RAW file software and Photoshop CS includes a RAW filter conversion as standard. When you open a RAW file in Photoshop the RAW interface is automatically launched [1]. From here you can select the white balance, colour temperature, tint, exposure compensation, brightness, contrast, saturation etc. Most cameras apply algorithms at the time of shooting, and this can often lead to slow performance, especially when shooting sequences. Shooting in RAW format produces a larger file on the memory card, but places total control of all aspects of the image in the hands of the user.

correct

Photoshop CS has an Adjustment called Shadow/Highlight. With this tool you can salvage most images. By default the Shadow/Highlight opens in a small window, and it gives a very basic quick fix to the very dark and light areas of the image [3]. To get the most from the Adjustment you need to expand the interface [4]. Then, finer adjustments can be made.

3 shadow/highlight

Shadows
Amount: 7 %

Highlights
Amount: 24 %

OK
Cancel
Load...
Save...
☑ Preview

☐ Show More Options

4 shadow/highlight

Shadows
Amount: 50 %
Tonal Width: 50 %
Radius: 30 px

Highlights
Amount: 32 %
Tonal Width: 50 %
Radius: 30 px

Adjustments
Color Correction: +64
Midtone Contrast: +2
Black Clip: 0.01 % White Clip: 0.01 %

[Save As Defaults]
☑ Show More Options

OK
Cancel
Load...
Save...
☑ Preview

1/ Shoot in RAW mode to avoid white balance problems.

2/ Original capture of the Welsh church in very low light conditions.

3/ The Shadow/Highlight basic settings.

4/ The Shadow/Highlight advanced settings.

5/ The final image corrected using the Adjustment.

5

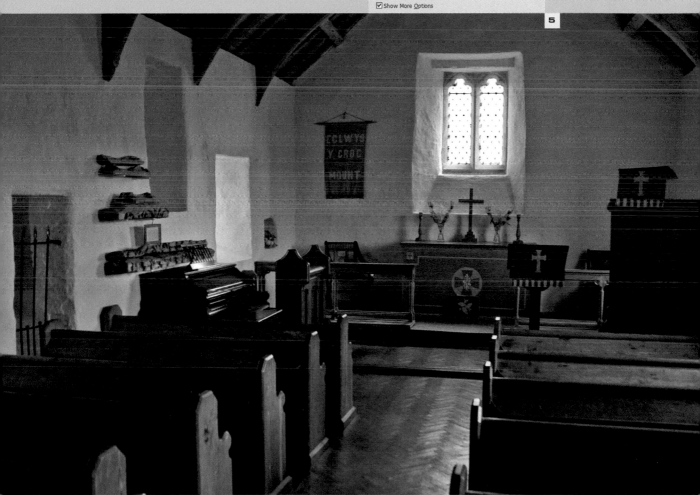

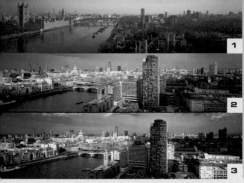

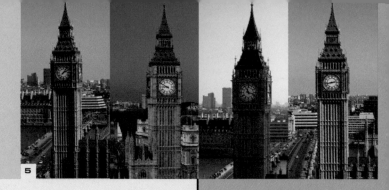

selections & masks

One of the main advantages in most imaging software applications is the ability to make an accurate selection of a single element or multiple elements within an image. Once a selection has been made, you can either cut it out, and paste it into another image, or make a localised adjustment without effecting other parts of the picture.

capture

Kevin Griffin was commissioned to supply the photography for a Eurostar advertising campaign. The brief was to show how frequently the Eurostar trains ran from London to Pairs. Working from the concept layout, Kevin shot several panoramic pictures of the London skyline and a series of shots of Big Ben.

Chris Christodoulou was given the task to composite the various picture elements to create a picture that could be used for a major poster and magazine advertising campaign. Barco Creator software was used for the project; this has many advanced features including a Chroma Matte Mask and a Line art tool for making very accurate selections. The equivalent tools in Photoshop would be the Pen tool and Color Select.

edit

The first task was to make up a background. The panoramic shots (1/2/3) were scanned and elements were taken from each image for a montage that would form the base image. Buildings were rearranged to make a visually interesting shot. However this also caused some perspective problems which were solved with a perspective distortion. A more interesting sky was also added (4).

The shots of Big Ben were photographed from adjacent buildings (5). Kevin had to ensure that each shot was taken from approximately the same height. The towers were cut out using the Barco Creator Line art tool (Pen tool in Photoshop).

The finer details were selected using the Chroma Matte mask which recognises very subtle

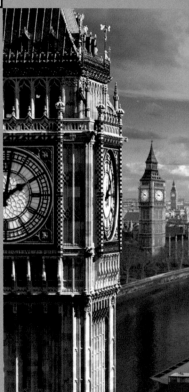

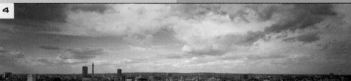

! **When making montage pictures like this, you can never have enough material. Shoot as many pictures as possible and reject the unwanted shots at a later stage.**

shades of colour. This is a sophisticated version of the Color Select feature in Photoshop (6). Here we have used Photoshop's Colour Select and transformed the clock outline into a mask, this method of selection preserves the delicate details in the tower. Each of the Big Ben shots was

> **!** Whilst drawing out a selection using the Marquee tool, hold down the Space bar to reposition the selection, release the space bar to continue drawing out.

cut out in the same way.

The Big Ben cut-outs were pasted and resized on to the London backdrop. The Big Bens in the distance were slightly blurred to give a feeling of depth. The times on the clock faces were manually adjusted to fit in with the copy line on the advertisement.

The colours on each element were corrected using multiple Layers and Adjustment Layers (7), ensuring the overall colours of the image would be consistent. The final 250MB composite image took five days to complete.

1/2/3/4/5/ The original captures.

6/ Layers mask in Colour Select.

7/ Colour corrections in multiple and Adjustment Layers.

8/ Big Ben photographs by Kevin Griffin retouching by Chris Christodoulou at Saddington & Baynes

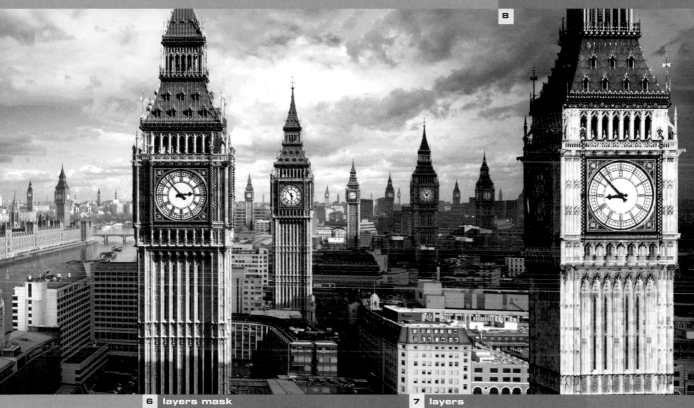

8

> **!** Adding a Feather value before drawing out a Selection will give a smoother border, experiment with different values depending on your image.

6 layers mask

7 layers

Photoshop CS has an excellent set of selection tools, each has its own advantage for different types of images. Knowing which tool to use for a particular image may not always be obvious. The true skill is in making the selection look seamless so the edges don't give away the fact that it is a selective part of an image. There are several selection tools that can be used.

1 | colour range

! When using the Magic Wand, press the Caps Lock key to show the precise cursor, now you can accurately click on a chosen colour.

selective techniques

Marquee Tool (press the letter M): in its basic form use this tool to draw out a rectangular selection. Hold down the Shift key at the same time and the selection is constrained to a square. Hold down the Alt key and the selection is drawn from the cursor position outwards – holding down the Shift and Alt keys produces a square from the centre outwards. The Marquee tool also has a fly-out option for drawing an ellipse or circle. To draw a perfect circle hold down the Shift key or Alt and Shift to draw from the centre out. There are two other options, single row and single column Marquee. The last two options have little use unless you have a unwanted line running through your image.

Lasso Tool (press the letter L): this has three options – the first is to draw out a freehand selection. Draw an outline around your subject to make a selection, a graphics tablet will make this easier. Use the Polygonal Lasso tool to draw straight-edged lines between two points, this is useful for selecting architecture or other regular shaped objects. The Magnetic Lasso tool is useful for making a quick selection when the subject is on a high-contrast background.

Magic Wand: this tool makes a selection based on the colour you click. By using a high Tolerance value more pixels will be included in the selection. To avoid the selection being too big you can either lower the Tolerance or select the Contiguous button. This button forces the selection to only include similar colours if they are adjacent to each other.

The Pen tool (press the letter P): this is quite a complex tool to master but for creating highly accurate selections on objects, it is the best. The pen creates a vector line which can be moved or reshaped. A selection can be made from the lines.

1/ The Select > Colour range is a quick way to select areas containing similar colours. A colour can be sampled on the Color Range palette and this colour range then becomes the selection. On the example picture the red lettering was sampled, to increase the selected area the fuzziness slider was moved to the right, (moving it to the left reduces the amount selected).

2/ Buried within the filters is a powerful Extract tool. This enables you to draw over the edges of your subject to define them and fill the central area with a solid colour. The Extract filter works out the edge details for you.

3/ The Quick Mask tool gives you the option to paint out the areas you don't require or, by pressing the X key, you can repaint in areas that may have been accidentally painted out. Add a mask Layer to your Layer and then select the brush tool and press the Quick Mask button, now paint out the bits you don't require.

4/5/ Pavel Kaplun's layers.

2 | extract

3 | quick mask

! Use Adjustment Layers for composite pictures, you can alter the tonal values without destroying information contained within the actual image file.

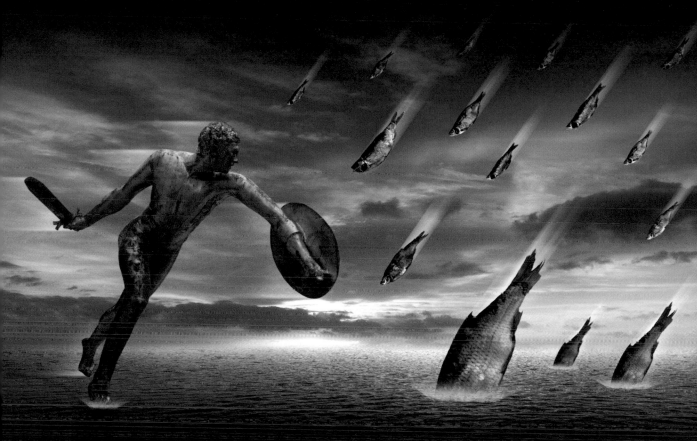

layer upon layer

'The Schutzschild' (The Shield) picture by Pavel Kaplun is made up from four separate shots. The fish, the statue, the sea and the sky. The sea and sky pictures were combined first, providing a suitable backdrop for Pavel to place all the other elements on to.

A mask was used to blend the sky and sea together. The colours in the sky were intensified with a combination of the Hue/Saturation Adjustment and Curves. Further Gradient Adjustment Layers were added to darken the top and bottom of the image.

The fish were cut out individually and pasted into several positions, each with its own masking Layer. A splash and trail were added to emphasise the movement. These were added as separate mask Layers.

The statue was cut out using the Mask tool and pasted as a new Layer.

The final image is made up of 50 Layers (4/5) and 21 Mask Layers and took Pavel over ten hours to create.

! Try to match the lighting of your new background to the cut-out, a diffused lighting will solve many problems later.

! Apply a Gaussian Blur to the new background to simulate a shallow depth of field, the values can be small or large depending on the effect you want.

! Shoot stock shots of skies, clouds and sunsets using a variety of focal lengths. These will come in handy for those times when you have a wonderful subject but a useless sky.

adding a new background

Most photographers specialising in studio portraiture will tell you that keeping a variety of background rolls is an expensive business. In the early 1970s and 1980s some photographers used a back projection system to add in a new background. This involved a model standing in front of a background and an image was projected at 45 degrees through a mirror placed in front of the camera – I never saw a realistic-looking picture created using this set-up and it was expensive to create.

Adding a new background to an image is not difficult and the movie industry has been doing it for years; the term they use is Chroma keying. The difficult bit is making it look convincing, especially on a high-definition, still photograph. Fortunately today we have some very powerful tools that can simplify the cutting-out process and dropping a new background has become easy.

cut-out tools

One of my favourite cut-out tools is Corel KnockOut; this application can be run as a stand-alone application or as a Photoshop plug-in. One of the major problems when making any selection is maintaining all the detail in the hair edges, KnockOut manages to preserve all the detail and yet, at the same time, blends the cut-out with the new background. An image must be transformed into a Layer first – I find it easy to duplicate the Background Layer to make a new Layer. Once in the KnockOut interface you have to define what is the image and what is the background, this is done by drawing a selection inside the image and then

drawing an outside border. Press the Process image button and preview the cut-out so that further adjustments can be made before making the final apply, which then returns the cut-out to Photoshop.

Not all images are going to be easy to cut-out, you will have problems with dark hair against a dark background for example. The best way to achieve a successful cut-out is to shoot your subject against a plain, but contrasting background. In the TV and movie industry they use a blue or green background and Chroma Key out the solid colour. If the presenter was wearing a blue or green shirt then they would be rendered with a see-through body. This is because the entire process automatically seeks out blue or green colours and eliminates them, regardless of where they are in the picture. With Photoshop and other imaging applications you are only working with a single frame, therefore you have more control on the area you want to remove.

simple backgrounds

Once you have made a selection, the next step is to find a suitable background.

One of the simplest backgrounds you can generate is the 'clouds' effect. From Photoshop select a blue foreground colour (or other colour). Create a new Layer and from the menu by selecting Filter > Render > Clouds. This generates a Layer of artificial-looking clouds (2). To give the background more visual appeal use the Ctrl + - (minus key) to reduce the image within the window and then select Edit > Transform > Scale. Whilst holding down the Shift key (to keep the correct proportions) drag a corner outwards to resize the clouds Layer. Resize this Layer until it looks visually pleasing (3).

Create ▶ Edit ▶ Sky & Fog ▶

Wireframe
Resolution
00:00:00.00

creative backgrounds

Perhaps you may have a selection of stock shots from all over the world, if not then you can purchase many royalty free CD picture collections with suitable shots. Make sure you can see the entire contents of the CD before you purchase as often you will find one or two

outstanding pictures and the rest of the CD will be padded out with sub-standard material. In the sample picture a plain studio wall was used with natural light, allowing the model to be placed on a wider selection of backgrounds.

Another option is to use virtual landscapes created by applications such as Bryce. The landscapes can look very convincing, especially if you apply a slight amount of Gaussian Blur to simulate an out-of-focus background.

5

> ! Keep the new background simple, that way the attention will be focused on the subject. Stock pictures of a scene tend to focus on a particular element, but you want interesting shapes that will complement your subject.

7

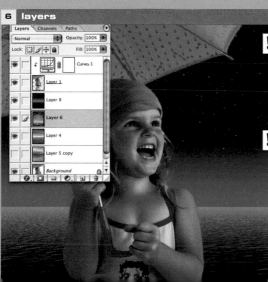

6 layers

> ! View the EXIF information of your images to see the focal length used, there is nothing worse than a mismatched new sky.

> ! Although cutting out a picture can be very effective, it is no substitute for actually taking pictures at a location – but it can be more economical.

4/ Creating virtual landscapes in Bryce.

5/ Studio shots using natural light allow a wider selection of backgrounds.

6/ Don't get carried away with applying a new background for its own sake, make sure that the new background makes sense to the picture content.

7/ The final image by Hans Claesson.

1/ The original picture of Lake Geneva.

2/ The local post office in Lausane. The flat soft lighting was ideal – at least now there wouldn't be any problems with contrast and shadows falling in the wrong direction.

3/ The Measure tool was selected (from the Tools under the Eye-dropper tool fly-out) and a line drawn following the Horizon line. Image > Rotate Canvas > Arbitrary was selected from the menu, and the correct angle for rotation was automatically entered.

> **!** Lighting is crucial for a convincing looking montage – you don't want elements photographed in bright sunlight with others in overcast conditions.

1

2

montage

Making montages from photographs has been popular from the outset in photography. Photo-artists would take individual pictures of various elements and then combine them to make up a final composition. Careful planning of a picture and of shooting the various elements was essential. This process was slow and often technically demanding – negatives had to be sandwiched together or prints physically cut up and glued in place. Today with digital imaging, things are far easier. Pictures need to be pre-planned and photographs taken explicitly to fit within the overall picture concept.

capture

In our example picture Jean-Sébastien Monzani combined several photographs to create 'The Drowning Castle' picture. The picture was inspired by the images of 'Taxandria', a comic book (and movie) by Schuiten and Peeters. On an early morning in February Jean-Sébastien was taken back by the wonderful quality of light and the serene tranquillity of Lake Geneva. Jean-Sébastien captured the image of the lake with his Olympus E-20 digital SLR camera (1). This would make a perfect backdrop for the montage.

Jean-Sébastien used a Canon PowerShot S30 to capture the chateau picture (actually it was the local post office at Lausanne) (2). Although the lighting was flat, it was ideal for the purpose Jean-Sébastien had in mind.

3 rotate canvas

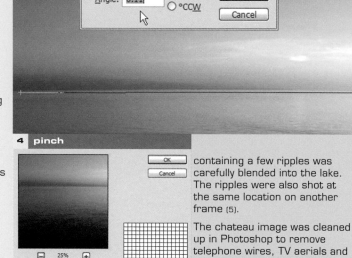

Angle: 0.11 ○ °CW OK
 ○ °CCW Cancel

4 pinch

OK
Cancel

25%

Amount 4 %

edit

The first step was to apply a small amount of image rotation to straighten the horizon (3). Using a zoom lens at its widest setting also caused a small amount of barrel distortion – not uncommon with wide to telephoto zoom lenses. This was corrected by applying the Pinch filter in Photoshop (Menu – Filter > Distort > Pinch) (4).

The seagull in the bottom right corner was removed with the healing brush and a new Layer

containing a few ripples was carefully blended into the lake. The ripples were also shot at the same location on another frame (5).

The chateau image was cleaned up in Photoshop to remove telephone wires, TV aerials and tram cables using the healing brush and Rubber stamp. The

5 layer

Layers
Normal Opacity: 100%
Lock: Fill: 100%
 brighter
 waves
 no seagull
 lens distort c...

> **!** Using Adjustment Layers will keep the image data intact so that it can be altered or undone at any stage. Applying curves without an Adjustment Layer would alter the data and you may not be able to recover the original values.

building was cut out by using the Magic Wand.

A Layer mask was created from the chateau. This was done by clicking on the thumbnail picture in the Layers palette and dragging it down to the Add Layer mask button. This allowed Jean-Sébastien to retouch on the mask itself, without destroying any of the image information – any retouching work can be simply undone using this technique.

The chateau Layer was not blending naturally with the lake so a solid colour Adjustment Layer was added. The lake was sampled with the eyedropper tool to ensure an accurate matching colour and the blending mode for this Adjustment Layer was set to Color. However, the new Adjustment Layer had also affected the underlying Layer. To keep any adjustments to the Layer mask only, place the cursor

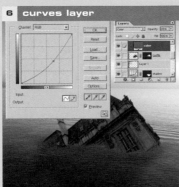

6 curves layer

between the mask and Adjustment Layer and hold down the Alt (Windows) or Options (Mac) key. An icon with two overlapping circles appears, click the mouse button. This has created a clipping mask for the Layer mask only. In our screen shot a Curves Layer has also

4/ The Pinch filter.

5/ The ripples in the water was a separate exposure.

6/ The shadow of the building was created by using a Curves Adjustment Layer with a soft mask.

7/ Some additional foam (and a bird) was copied and pasted from other pictures, scaled and rotated so that it matched the castle's position.

8/ 'Le Château Englouti' by Jean-Sébastien Monzani.

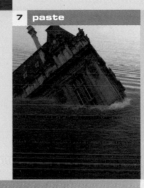

7 paste

been added (6). Make adjustments to blend the tonality of the two images together.

For the final image (8), Jean-Sébastien has added some waves, and a shadow/reflection around the chateau. A bird has been added in the sky which gives an uneasy feeling to this surrealistic image.

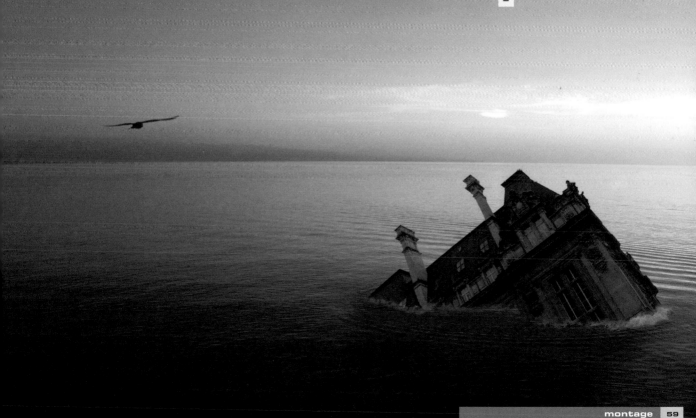

8

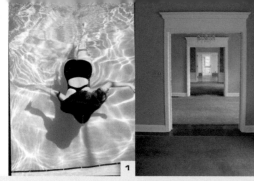

! Plan your pictures first and then shoot the elements you want to include.

! Experiment by trying different blending modes, they can produce unexpected results. If you don't like the result you can always Step Backwards or Undo.

! The ripple filter in Photoshop is not that convincing, a hefty stone will give a much more life-like ripple.

! A compact digital camera is easy to carry with you at all times and will come in useful for photographing small elements for a montage.

montage II

Patricia Gooden used three elements to make up her 'Journey' montage; a shot of clouds, the swimmer picture, and an empty room. All pictures were captured on an Olympus E20 digital SLR camera and manipulated in Photoshop.

3 | clone tool

sure the Background colour swatch is set to black and press the Delete key to clear the selection's content (if the Background swatch is white it will reveal the content). If the cut-out goes wrong then you can rework the mask as the actual image is not altered (only the mask).

The swimmer picture was dragged and dropped on to the masked room picture and then moved to the bottom of the Layer stack. The water area is smaller in width than the floor area. Using the clone tool Patricia filled in the missing areas.

A picture of clouds was added to fill in the panes of glass in the door at the rear. This cloud

5 | layers

6 | curves layer

Layer was placed above the swimmer, but below the room Layer. The tone in the room was lowered by adding a Curves Adjustment Layer. This was locked to the room only, so the underlying Layers would not be affected.

Finally, to add some waves against the walls, a new Layer was added above the room Layer and the water was cloned from the bottom Layer to this Layer. The clone tool can clone between Layers (make sure the Use All Layers option is checked on the Options toolbar).

! When using the Clone tool, sample similar areas from all over the picture to avoid re-cloning cloned areas again. A repeating pattern will spoil the overall effect.

edit

The first stage was to convert the room picture into a Layer, by double clicking on the Layer thumbnail. Next, the floor area had to be cut out of the room. The easiest way to do this is to create a Layer mask, click on the Add Layer Mask icon located at the bottom of the Layers Palette. Then highlight the mask icon and use the Polygonal selection tool to mark out the area you want to delete. Make

4 | layers

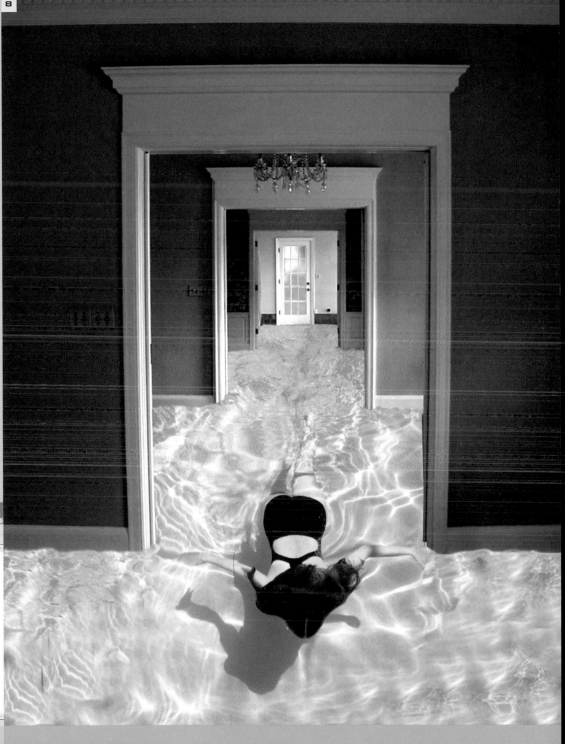

1/ The original swimmer photograph was taken in Patricia's back yard.

2/ An empty house nearby provided Patricia with an ideal location for a series of rooms to use as a visual metaphor.

3/ A Layer mask will assist in making an accurate cut-out. If it goes wrong then you can easily alter the mask while the image data remains intact.

4/ A shot of some clouds was added and again moved below the room Layer. The clouds are visible through the rear glass door.

5/ The swimmer picture was dragged and dropped on to the masked room and then moved to the bottom of the Layer stack. Working on the bottom Layer, the water was cloned to fill in the missing areas.

6/ A Curves Adjustment Layer was added above the room. The brightness of the room was lowered to give emphasis to the swimmer. Adjustment Layers add the effect to the Layer without actually altering the image, this is called a non-destructive adjustment.

7/ A blank new Layer was added to the top of the Layer stack and the water was cloned into this to give the effect of splashing against the walls.

8/ 'Journey' by Patricia Gooden.

7 **curves Layer**

1/ 'Summer Exhibition at the Royal Academy' by Hugh Gilbert. Hugh Gilbert specialises in panoramic photography and has been commissioned by many leading companies including the Dutch tourist board to produce some stunning pictures. Hugh uses a Nikon D1X camera fitted with a 14mm wide-angle lens and shoots up to 24 shots, perhaps only using 12 for the final picture. Hugh enjoys using digital media because of the immediacy it offers and the ability to review the pictures whilst on the location. The downside is that in order to achieve great results a lot of time and technical expertise has to go into each image. Some of Hugh's pictures can take up to several hours to complete. Hugh hasn't abandoned film, he still shoots panoramas using a Spheron camera with a 20mm F8 lens. This camera is capable of taking pictures 180 degrees by 360 degrees.

panoramas

Even when using the widest lenses available it can be difficult to capture an entire scene without adding severe distortions. One way to get around this is to use a dedicated panoramic camera. There are many available, some use a long film format (up to three frames on 35mm film, or 6 x 7cm on roll film). The angle of view ranges from 90 degrees through to a full 180 degrees and there is even a camera that rotates to capture a full 360 degrees.

Digital photography has a solution for most photographic problems and creating panoramas is an easy task. There are many software packages available such as PhotoVista and 3DvistaStitcher, that will link together a sequence of pictures. I have tried several but the one that produces excellent results time after time is a mini application called Photomerge which is included with Photoshop CS and Photoshop Elements. (Menu – File > Automate > Photomerge.) Using this mini application is very easy; you load a sequence

of pictures and Photomerge does the job for you and the results are very good.

Things are never as simple as pressing a couple of keys however, and the secret of a successful picture is in how you take it and then how you interpret the same picture. The temptation is to utilise a wide-angle lens to its fullest, But it also captures barrel distortion, light fall-off and other optical distortions at the edges of the frame. A much better method is to shoot the sequence in portrait, or upright mode. Now you don't need to

use such a wide-angle lens. Switch to a slightly longer focal length and most of the distortions will vanish. A series of 12 exposures should be enough to make a 180 degree picture.

For shooting a panorama sequence, use a sturdy tripod with a good pan and tilt head for absolute accuracy. Ideally, the head should have a spirit or bubble level. Rotate the head prior to taking the pictures to ensure that the level remains constant throughout the entire sweep. Set your camera to manual mode and take an

1

exposure for the entire scene, this way all the frames are going to be of a similar density. Capture your pictures starting at the left (or right) edge and make sure that the next frame overlaps the previous one by at least 25 percent. If your tripod head has markings then use these for absolute accuracy.

! **Use a sturdy tripod with a panoramic head. This ensures that the lens rotates around an exact centre, otherwise shadows or image blurring can occur.**

! **Meter for an average exposure that will give detail in the shadow and highlight area, and don't change the settings half way through the sequence.**

! **Look at the scene whilst taking a sequence and make sure that if there are people about, they are not walking in the same direction as your pan – you could end up with a 12 shot panorama with the same person repeated.**

2/ 'Medieval Buildings' by David Pichevin. David Pichevin's picture uses a different technique. Here, David kept the camera flat on to the buildings and moved along sideways to capture the next section. This method makes it easy to keep a flat perspective on the buildings, but requires careful alignment of the camera for each frame. The perspective controls, together with the grid in Photoshop, will help to keep things straight. Rotating the camera on a tripod would not give the same effect as the furthest parts would be smaller than the centre, thereby introducing perspective.

2

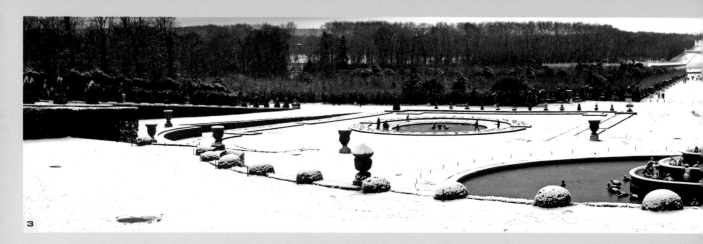

3

3/ 'Gardens of Versailles' by David Pichevin. David Pichevin shot a sequence of 11 pictures using a Canon PowerShot G3 to capture this snow scene in Versailles. David shot the pictures in the horizontal mode starting the first sequence from the centre to ensure the fountain was captured in a single frame, he then shot the frames moving to the left. The second sequence was shot from the centre to the right. The pictures were all manually joined together using the Layer opacity slider to ensure an accurate join. The opacity was returned to 100 percent when the join was in the right place. Once all the pictures had been joined together David corrected the image for exposure and colour. The photos were deliberately underexposed to keep some detail in the snow. David cleaned up small details in the final panorama with the Rubber stamp tool. This was to remove ghosting where people in the background had moved during the capture of the sequence.

4/ A sequence of 13 frames make up the Gardens of Versailles picture. Careful planning is essential to make sure each part of the scene is captured.

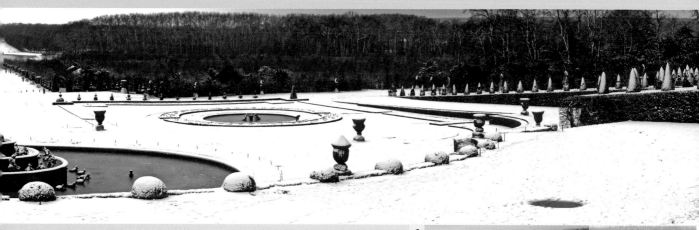

> **!** Taking pictures of waves breaking along a coast line is far more difficult. On such an occasion it may be better to shoot in the horizontal mode. Again, shoot quickly and be prepared to do some manual joining.

> **!** Not all inkjet printers are capable of printing panoramic pictures. Selected Epson printers, especially the large format ones, have the ability to print on roll paper. There are several media surfaces available, the fine art media is well suited to longer pictures due to the low reflective qualities.

5/ 'Scotney Castle' by Vincent Oliver. This 180 degree photograph of Scotney Castle and grounds was shot using a Nikon D1 camera fitted with a 24mm lens. The sequence of 12 pictures were loaded into Photoshop's Photomerge application. Careful editing is essential – if you have too many shots then the overlaps can become blurry, this is due to the software trying to overlay several images in the same location. The final picture was made up of just seven images and produced a 30 x 9inch print. To add a final touch, an artificial sky was added, created in Digital Elements Aurora 2 software. The sky was blended with a Layer mask to merge the join.

> **!** On cloudy days when the sun is in and out, wait for a constant light before starting the sequence, or work fast.

> **!** Adding extra sets of plug-in to Photoshop will slow things down considerably. The best method is to only load the plug-ins that you are likely to use. This can be set-up from the Preferences > Plug-ins and Scratch disk. You will have to re-launch Photoshop for the new set of filters to take effect.

1/ All the correct monochrome tones have been applied using the three Adjustment Layers technique.

2/ This image was converted to monochrome by using a quick Desaturate. Tonal values are not correct and the image looks dull compared to the first shot.

3/ Photo filter in Photoshop CS simulates an 81b warming filter.

4/ Applying Photo filter to a layer avoids loss of data in the original image.

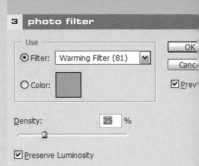

special effect filters

Filters are an important accessory for any photographer, and whether it's a yellow, orange, colour correcting, polarising or graduated glass filter, we all have a collection of them. The trouble with using filters is that you commit the picture to the effect. With digital imaging you can forget about glass filters and apply a similar effect in an imaging application with greater control and with the ability to revert back to the original if you are unhappy with the result.

filters

The term photographic filters has just been redefined, a filter now means a plug-in or mini application that will achieve a particular effect. Just about every imaging application has a set of bundled plug-in filters, and these can range from colour variations or artistic brush strokes to more complex lens flare and lighting effects. Photoshop includes a generous supply of plug-in filters that should satisfy most photographers' needs. Filters can be applied to almost any image and you can use several filters in combination.

a retro step

If you have just moved over from film photography, then you will be at home with coloured glass filters, but did you know that you can create a similar effect with Photoshop's built-in filters? If you are used to working in monochrome then this is still possible, but just start shooting everything in colour from now on and you can convert the image to b&w at a later stage.

To simulate an 81b warming up filter using Photoshop CS, use

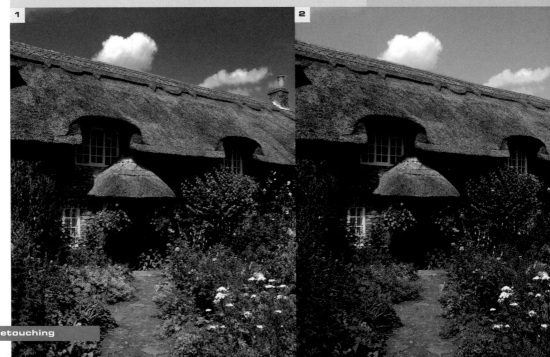

! A filter should enhance a picture, don't make it the feature of an image.

5 lightning

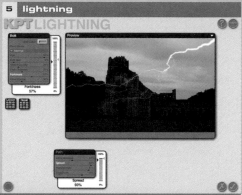

KPTLIGHTNING

5/ 6/ 7/ Kai's filters, available through Corel, include many oddities such as Lightning, Lensflare and Channel Surfing.

! Filters can be combined to produce some fantastic results. A good way to experiment is by duplicating a Layer and applying the filter to the duplicate.

4 photo filter

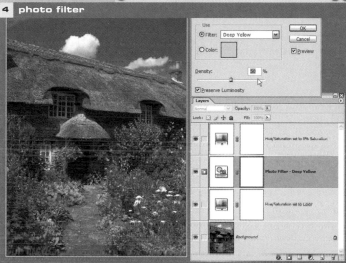

6 lensflare

KPTLENSFLARE

7 chanel surfing

KPTCHANNEL SURFING

the new Photo filter (Image > Adjustments > Photo Filter) and select the filter from the drop down menu (3). A better way to use this filter would be to create a Photo Filter Adjustment Layer, adjust the values by double-clicking on the Adjustment Layer (4).

The Photo filter also works with b&w images. Create two Hue/Saturation Adjustment Layers, place the first one immediately above the background image and set its blending mode to Colour. Position the second Adjustment Layer on the top of the stack

and set this to Normal with the Saturation value set to -100%. Now Create a new Photo Filter Adjustment Layer with a Density of approx 50% and position it between the two Hue/Saturation Layers. Select a Red, Yellow, Deep Yellow, Green etc. filter and the effect will be exactly the same as using a conventional glass filter on b&w film.

more filters

Photoshop has numerous built-in filters and the effects can be quickly previewed using the Filter Gallery. The gallery gives near instant previews of the filters and multiple filters that can also be applied. The one missing feature is the ability to save your settings or combination of filters used.

There should be no reason to tire of the available filters with Photoshop, but should you want something extra then there are several companies who provide additional plug-in filters. The most famous supplier is Kai's Power Tools, these are available through Corel. The filters are weird and wonderful, with very quirky interfaces. Perhaps the most overused filter of them all is Kai's page curl (1), but it was so overused that it became clichéd, and so undesirable.

Another interesting filter comes from JASC (Paint Shop Pro) it's a small inexpensive application called Virtual Painter (2). This plug-in also works with Photoshop and transforms any picture into a 'work of art'. The interface is simple to use, the previews are not that accurate but fortunately the end result always seems better than the preview (3/4).

Adding some sunshine into a picture is no problem with the sunshine filter, which is one of several filters included with nik Color Efex Pro. No photographic filter set would be complete without a polarising filter. Of course polarising filters can be used with digital cameras, but for those

! There are hundreds of plug-ins available for Photoshop and other compatible applications, do a search on the web. Most will allow you to try before you buy, usually for 30 days or with other restrictions.

2 virtual painter

Material + Rendering + Colors + Deformation + Focus +

Material	Normal
Rendering	Normal
Colors	Intense
Deformation	Normal
Focus	Normal

Impasto
Smooth Paper
Choose the desired effect.

OK Help Cancel

Material - Rendering - Colors - Deformation - Focus -

! Use your Layers blending mode for extra permutations.

! Shoot everything in colour, it's an easy process to convert your images to b&w at a later stage and you will have far more control over the way your image tones are rendered.

3

4

occasions when you forget to
take it with you, the nik Color
Efex polarising filter (5) will work
surprisingly well. On this

screengrab the filter was
applied to the left image, the
right being a duplicate of the
original image (6).

5 nik color efex pro

Polarization
nik Color Efex Pro

1:12

Rotate Filter 78°

Strength 182 %

Save Load Help Cancel OK

6 polarize

1/ The page curl filter from
Kai's Power Tools.

2/ 3/ 4/ Virtual Paint filter
from JASC.

5/ 6/ Using Nik Color Efex Pro's
polarising filter.

4 shooting digitally

'Bus Stopped' by
Marlene DeGrood

A lucrative area in photography is shooting for stock. This is the term used for creating images for picture libraries. Picture libraries are a one-stop point for people who need a specific image. An art director or designer might be looking for a location picture to use in a brochure, or a lifestyle image that reflects current trends. A good library will be able to supply a selection of pictures, so that one may meet the designer's brief. The internet plays a major role in today's library, and virtually all have a website where images can be viewed; a customer types in a few keywords and a selection of pictures are presented on a 'lightbox', from here the client can either download low-resolution images (for layout purposes) or order the full-resolution images immediately. Chosen pictures are delivered online or on CD, very few libraries today send out transparencies.

Picture libraries have thousands of pictures covering just about every subject; travel, business, lifestyle, sport, finance, children etc. There are also specialist libraries that cover sport, personalities, theatre,

shooting for stock

! The old way of thinking was to put spare pictures into a picture library. Today, this approach will not reap many rewards. It is better to be hypercritical and only submit the very best pictures.

capture

A picture was requested to sum up unemployment and job seeking and the concept was planned out well before the shots were taken. Knowing exactly what the picture message is going to be makes everything easier.

edit

The job section of a broadsheet newspaper was photographed with an 11Mp digital camera as it was too big to scan on a flatbed scanner. The first adjustment was simply to increase the contrast in Levels (2).

The page was selected, copied and pasted as a new layer. This layer was then distorted with the Transform tool (Edit > Transform > Distort) to add perspective to the page (3). This was judged by eye.

1

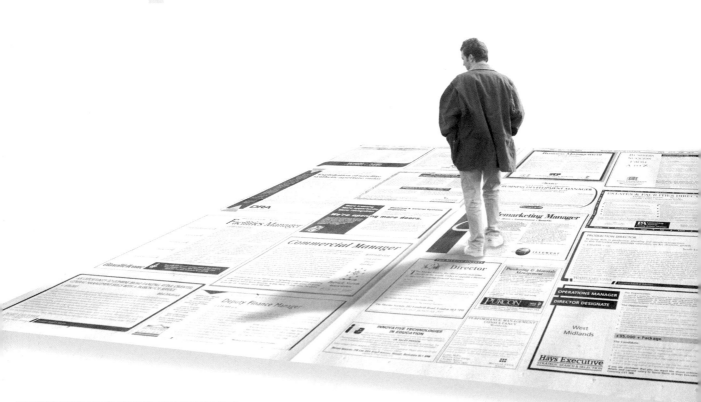

cinema, news, medical, animals, industrial etc. if your photographic interest extends beyond the scope of a more general picture library.

Shooting for stock is invariably done on a speculative basis i.e. photographers finance the shoot themselves. This means an investment in time and money; costs can soon mount up if models and locations are involved, and pictures are not always accepted. Generally a photographer will be advised by a library art director on the material and style that is in demand. Once pictures have been accepted then they are added to the library database. Depending on the image and the library, there can be a considerable gap between submission and receiving fees. If the photograph sells well then any costs will be recovered very quickly, a good library can market pictures on a global scale, tapping into a potentially vast market.

1/ 'Paper' by Vincent Oliver.

2/ Adjusting the levels to increase contrast.

3/ Adding perspective in Transform.

4/ Matching the tone and contrast of the Layers.

5/ Scaling the figure.

6/ Creating the shadow.

! **Browse the libraries to see what the current style of photography is.**

The jobseeker was my assistant walking in a park, where a variety of shots were taken of him looking down to the left and right. The final image was matched with the newspaper for tonal values and contrast (4). The man was then selected and cut out. The pictures had to be taken from the right height and making sure the man

2 levels

3 free transform

was looking in the right direction so that the two images would combine.

The next stage was to paste the man on top of the newspaper. Again the Transform tool was used, but this time the Scale option was selected (5). The figure was resized to the perspective. Holding down the Shift key whilst resizing will constrain the scale proportionately. Final adjustments were made to the newspaper's position for a 'natural-looking' perspective.

A duplicate layer was made of the cut-out figure and the Levels were adjusted by moving the sliders over to the far right. This removed all the tones from the image, leaving a silhouette. A Gausian Blur was applied to the Layer and its opacity was lowered to about 30%. The Transform > Distort tool was used to convert the layer into a shadow and the Eraser tool cleaned up the shadow areas under the shoes.

This image highlights the importance of pre-planning. Not every shot requires this amount of preparation of course, but in a competitive market a good concept can make all the difference. This particular image involved just a small outlay and it continues to be sold worldwide.

4 curves 5 transform 6 levels

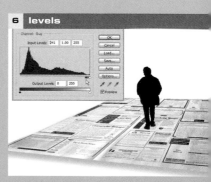

preparing the files

Traditionally libraries have requested large-format positive film, 6 x 6cm or larger. In more recent years 35mm transparencies have become the standard. Now as the quality of digital cameras has increased, digital formats are now being accepted. However, digital camera submissions should be made with cameras that have a minimum of 6Mp. Libraries generally require a minimum file size of 48–52MB. Pictures shot with a six mega pixel camera are about 17MB in size, whereas an 11Mp image is 31MB file. These figures are for straight files, if you crop the image then obviously the image size will be smaller. Before submission the files have to be interpolated up to 48MB. There are a few applications that can do this, such as Genuine Fractals and PhotoZoom Pro, but Photoshop CS has an improved Bicubic interpolation which produces equally good results.

interpolation

The sample 6.78MB image has been increased by 300 percent to a 49.44MB file. This is far too much interpolation but it shows how much quality can be squeezed from a digital file. An 11MB file only needs to be increased by 127 percent and a smaller interpolation will yield better quality. Photoshop's Bicubic interpolation is very good, but there is some excellent interpolation software available. PhotoZoom Pro 1 was used in our screenshot.

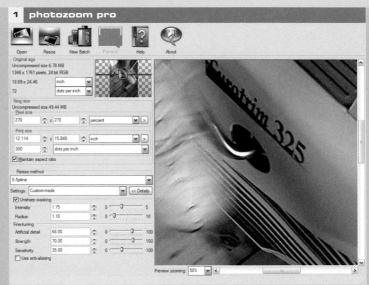

1 photozoom pro

identification

A key stage is to caption the image. Each library has their own system for keywording and entering keywords (a description of the image, location etc.) and other relevant submission information. This information can be stored in the File via Menu > File Info.

Depending on the picture library, photographers can send in low-resolution sample pictures or place them on a website. From here the picture editor can choose which pictures they want. Final submission is made on CD, generally just one image per disc to avoid any mistakes, together with a print of the image – this saves the editor having to open up every disk just to see what's on it.

2 captioning

1/ Using PhotoZoom Pro to interpolate an image to improve its quality.

2/ Advanced captioning allows keywords to be applied to the image for search engine recognition.

3/ 'Control' by Vincent Oliver. The Control key on this keyboard has many messages which makes it a popular image for sale. The shot was fairly quick to produce: the keyboard was photographed with a Nikon D1 camera fitted with a 20mm lens and multicoloured lighting was used. The resulting shot was dull, so the saturation was increased to +100 in the Hue/Saturation dialogue box, which livened up the overall image. Further tonal adjustments were made using the Curves. Finally the 7.5MB image was interpolated up to 50MB ready for submission.

! Pictures depicting finance, banking and investment are the big earners, followed by lifestyle shots. Landscapes may be fun to do, but they won't make you a fortune.

4/ 'We Are One' by Dieter Frangenberg. A combination of Photoshop and Poser software was used to make up this montage. Careful planning and an original concept can make all the difference between a good and a great picture. Dieter's picture has many messages embedded within it, it's now up to the individual client to see if their own message can be conveyed with this picture. The image could be used for Medical and Family care, Insurance, Building societies and Finance companies.

5/ 'Retirement' by Vincent Oliver. With the population living longer and having greater spending power, it goes without saying that the financial opportunities for companies targeting this sector are enormous. This shot of an elderly couple enjoying a sunny day out has sold countless times. The temptation was to drop in a sunset as a background, but this would have been too obvious. The message for this picture is 'the future looks bright'. It was shot with a Nikon D1.

Once the model was selected, a daylight studio was booked. The image was for a Spring/Summer issue and a light touch was needed. A hat was planned to reduce the prominence of the face and to concentrate attention on the mouth, summery clothes were also chosen. In the event the day was gloomy, none of the hats worked and the clothes didn't really cut it either. The beauty editor was in Milan and Nick was in London, both trying to sort out a solution on the phone – pretty much a recipe for disaster. Nick realised that some drastic post-production was going to be necessary.

1

shooting to a brief

Every photographer likes to do his or her own thing, having the freedom to roam around and take pictures of things that interest you has to be the ultimate luxury. But the going gets tough when you have to shoot to fit a layout and come back with striking images.

the brief

Nick Scott is a fashion photographer who has worked for most of the leading fashion magazines. He was commissioned by the beauty editor of Italian 'Vogue' to do this shot.

They were already running late with publication deadlines and so everything was a bit rushed. The brief from the editor was rather vague, other than that the image was to feature a new lipstick colour. The first task was to cast the model, about 20 girls were called in, giving Nick the opportunity to see the models' lips at first hand. Naturally it was important that the mouth was right as it was to be the focal point of the shot. Although most photographers make an initial selection from models' cards and agency books, it is still important to see the models at first hand since it is not uncommon for portfolio pictures to be one or two years out of date.

2

effect and suggested that the model's right shoulder be dropped a little. The chosen image was drum-scanned and the shot manipulated in Photoshop. A provisional low-resolution version was emailed for approval. A few adjustments were made and then a final high resolution version was posted on Nick's server so that it could be downloaded ready for publication.

edit

The processed film was scanned and a selection of the best shots were emailed to the editor. Over the phone they made a choice based on the mouth and then discussed what could be done to make the shot work. Nick started by roughly making a heavy shadow over one eye and lifting the lighting on the other. Working with low-resolution files made it possible to email these across as they were talking on the phone. The editor liked the

3 liquify

4 layers

1/ The original scanned picture without any adjustments.

2/ Shadows were created by making a freehand selection using the Lasso tool before filling with black. Adding a feathered edge meant that there were no harsh lines.

3/ The shoulder was reshaped using the Liquify filter in Photoshop, which enables you to pull and push images into shape.

4/ The left eye was copied and pasted as a new layer and then the shadow was reduced with a Curves Adjustment Layer. The lips were also copied and pasted as a new layer, these could now be adjusted independently of the rest of the picture using a Hue/Saturation Adjustment Layer.

5/ For the final image the model's skin tone was lightened, the neck area was cleaned up and an overall soft-focus effect was applied. The lips and eye were left sharp.

Make-up: Anna Scott.

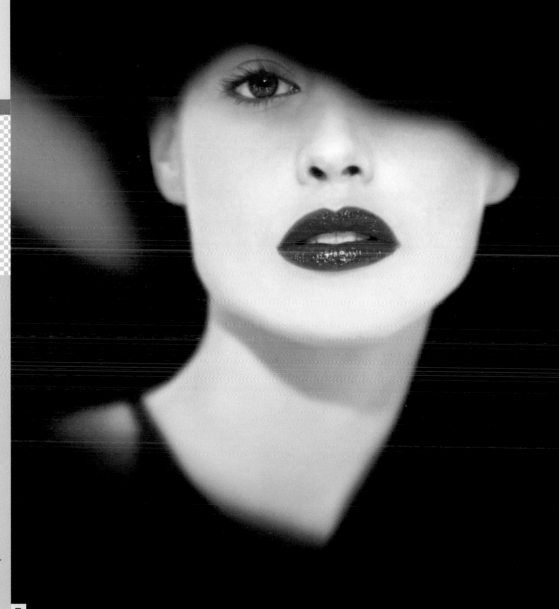

5

1/ Patricia photographed the Japanese girl on her Olympus E-20P digital camera.

2/ The model's white make-up was selectively cleaned up with the Dodge tool, to lighten the darker areas.

3/ A duplicate layer was created and a Curves Adjustment was made to darken the overall image. Patricia then used the Eraser tool with a large soft brush to erase the central face area, which revealed the underlying original layer. The centre of each flower was erased.

calligraphylayers.tif @ 100% (Background, RGB/8#)

4/ A poster with Japanese calligraphy was photographed at a Bonsai tree fair in Montreal and reduced to a high-contrast b&w image. This was added as a new layer and the Blend mode was set to Multiply. This removed all the white areas and allowed the underlying face to show through.

5/ Photoshop's File Information palette conforms to the IPTC standard (International Press Telecommunications Council).

! Try to get as much right as possible at the shooting stage and don't rely too much on an image-editing application to save the day.

! Photographers have always made an extra mark up on film and processing. Today clients expect you to retouch your own work, so make sure that you charge for this service.

3 4

details

One important thing to do with any image submitted for publication is to embed the details of the shot, the captions, your name and your contact details within the file. Picture desks receive many images each day via email and on disc and the chances of caption sheets becoming separated from an image are high. The image information can be added via the File Information panel (Ctrl + Alt + I). Enter all the information that you feel is important to your picture, then there can be no uncertainty of whose image it is.

! Ask the publication what size they want the file; generally files should be 300dpi for print publication or 72dpi for web and multimedia display.

be creative

One of the key qualities for any photographer is resourcefulness. Elements from many sources can be brought together to make up a final image. On this photograph of a Japanese model Patricia Gooden applied a small amount of manipulation and added some Japanese calligraphy to finish of the picture. A few years ago this would have been the job of a skilled retoucher, today a photographer must have a good repertoire of tricks and retouching skills to participate in a very competitive area. Knowing when to stop is also an important stage, the temptation is to continue making improvements, but a point will be reached when the improvements are too minor to be cost-effective or the image will start to suffer through over-manipulation.

Description
Camera Data 1
Camera Data 2
Categories
History
Origin
Advanced

Description

Document Title: Japanese model

Author: Patricia D. Gooden

Description: Japanese model with calligraphy overlay

Description Writer:

Keywords: Japan; Japanese; Calligraphy; Model; Flower

Commas can be used to separate keywords

Copyright Status: Copyrighted

Copyright Notice: This image is the copyright of Patricia D Gooden and may not be reproduced without permission.

Copyright Info URL: www.goodenart.com

Go To URL...

Powered By xmp

Created: 09/06/2004
Modified: 05/07/2004

Application: Adobe Photoshop CS
Format: image/tiff

OK Cancel

wedding photography

Wedding photography requires just as much skill as any other photographic assignment. Photographers must have a sound technical background so they can deal with any situation quickly. A wedding is a 'one-off' occasion that can't be repeated, everything has to be absolutely right on the day.

For years wedding photography has been dominated by medium-format cameras, mainly due to the larger negative and the camera's ability to synchronise with flash at high shutter speeds. Today more and more photographers are switching over to digital cameras, which offer many advantages over film. A 6Mp SLR camera will deliver sufficient quality for print sizes up to 20 x 16inch, but framing should be accurate to avoid cropping into smaller areas. For maximum quality a 11–14Mp camera is ideal, this will produce quality that rivals most medium-format cameras.

capture

Here is a workaround for a typical job that you could modify for your own use. The example picture was taken at Gail and Mark's wedding, using a 11Mp camera [1]. The picture is flat and there is an abundance of green reflected light.

edit

The image was converted to monochrome using two Hue/Saturation Adjustment Layers [2]. The top Adjustment is a straight Desaturate to –100 on the Saturation slider, this removes all the colour but still keeps the image as a three channel RGB file.

The second Hue/Saturation Adjustment Layer's blending mode has been set to Color, this layer must be placed under the Desaturated layer. Now move

the Hue slider and observe the changes in tonality on the monochrome image [3]. The tonal changes are very similar to using a traditional glass filter with monochrome film.

There are several methods for converting an image to sepia, but the method that gives the greatest amount of control is Duotones. Duotones have their roots in the lithographic industry as toned photographs in books and posters. Photoshop has a number of Duotone presets that you can tweak to taste. Change the image mode to Greyscale – Image > Mode > Greyscale. This will remove all the Adjustment Layers, so make sure the image tone is right first. Now change the image mode again, to Duotone. You can only convert a Greyscale image to Duotone.

On the Duotone palette select Load. Navigate to the Tritone presets folder and select a suitable file, you will have to experiment to find one that you like [4/5]. Double-clicking on the small curve thumbnail opens a tone curve which you can alter to suit your own image or double

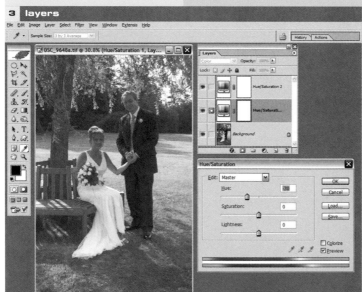

1/ The original capture.

2/ Adjust Hue/Saturation levels using two different Layers.

3/ Changing the Hue on the bottom Layer.

4/5/ Converting to sepia using duotones.

6/ Adding a frame.

7/ The final image.

click on the colour swatch to change the colour. Save your custom preset for future use. When the image is finished convert it back to RGB via the menu – Image > Mode > RGB Color.

With the sepia tone applied, duplicate the layer and then apply a Gaussian Blur to the top duplicate layer. Use a Radius of 7–10 depending on your image size. The image will now look

totally out of focus. Now alter the Layer's Opacity to about 50%. The image will be sharp but yet have an overall romantic glow, an effect similar to an

expensive Softar filter.

An Extensis Photo Frame filter was applied to the image to add a finishing touch (6). Photoshop and Paint Shop Pro has a few predefined actions and Frames that will give similar results.

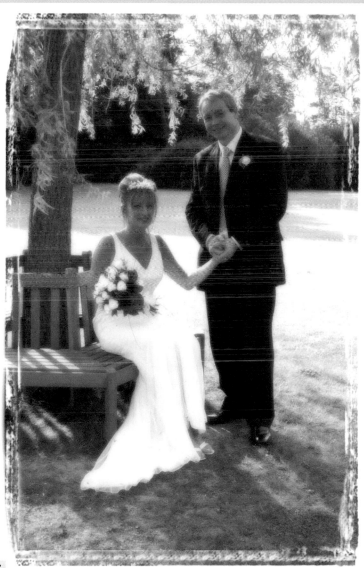

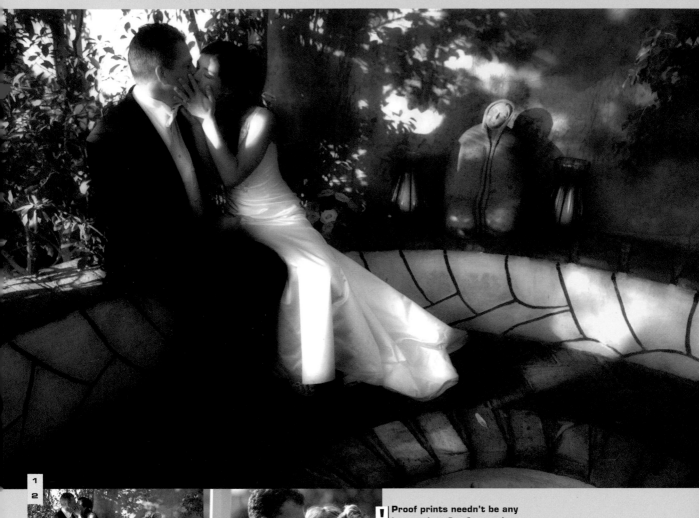

1
2

3

4

! **Proof prints needn't be any larger than 6 x 4cm and you shouldn't worry too much about the longevity of these prints, print speed is the primary consideration.**

1/2/ The colours have been emphasised by creating a duplicate layer and the Blending mode changed to Multiply, a Curves Adjustment layer was used to lighten the picture again. A hint of Gaussian blur gives the picture a soft touch.

3/4/ A superb colour picture by David Beckstead has been transformed into a stylish image by using Adjustment Layers, soft focus and grain (noise).

proof prints

A photographer who can deliver a set of proof prints to a wedding reception is going to be at an immediate advantage. Guests will be swept away with the occasion and will no doubt place an order for a few pictures. Producing proofs in the past meant rushing back to a lab to get the film processed and returning to the reception with a handful of prints.

Armed with a digital camera, a decent laptop computer and a photo-quality inkjet printer, today's digital photographer is better equipped to provide instant approval and benefit from an increase in sales.

Alternatively a set of proof pictures can be delivered on a CD/DVD. A small inexpensive application called Pictures to Execute (5) will generate a slide show within a few minutes. The images are placed into a self-running data file, so there is no chance that anyone can copy them. The application has a time disable option, this means that you can leave the show with a client and after a chosen date the show will not run again. The time disabled version can be sold as part of your order.

The popularity of DVD players in the home has also opened up new marketing opportunities for sales. An entire collection of pictures can be written to DVD as a slide show and played back on the TV set in the living room. Using a suitable soundtrack will guarantee the mother-in-law's handkerchief sees the light of day.

Another option is to place the entire set of pictures on a website and reprints can be ordered online.

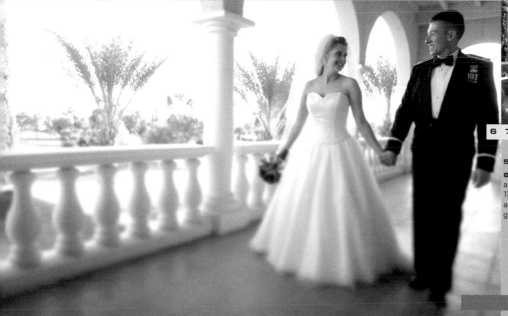

5/ The Pictures to Execute application.

6/7/ A super picture taken from a low angle adds to the overall image. Transforming the picture to b&w and adding a soft focus adds extra style and glamour to the day.

! For interiors, it is easier to shoot in **RAW** mode and correct the colours on the computer at a later stage.

architectural photography

Architectural photography has been dominated by large-format, 5 x 4inch cameras, primarily due to the fact that you can use the rise and fall feature to correct converging verticals before committing the picture to film. This feature alone makes a large-format camera the ideal tool for architectural photography. Large-format cameras have also moved on into the digital age and there are digital film backs available, notably from Phase One and Sinar. The digital back fits on the camera in much the same way as a conventional film holder and a photographer uses it in exactly the same way. The image is composed and adjusted using the camera's ground-glass screen and then the digital back is fitted for the actual exposure. There are several options including backs that are self-contained (i.e. they have a memory card and **LCD** monitor), and backs that must be tethered to a computer (or laptop for location work).

35mm users are also catered for with image-shift lenses, both Nikon and Canon have perspective control lenses in their range. Nikon has two; the 28mm 3.5, and 85mm 3.5, while Canon has three shift lenses; the 24mm 3.5, 45mm 2.8, and 90mm 2.8. These tilt/shift lenses produce the same corrections as large-format cameras but with the convenience of using a 35mm camera. The Canon shift lenses can also be used with their range of digital cameras, but to get the full coverage of each lens the full-frame Canon 1Ds should be used. Other Canon digital **SLR** cameras have a **1.5X** magnification factor, this means the 24mm lens has the same angle of view as a 37mm lens. The 85mm and 90mm lenses have limited use for architectural photography.

capture

One of the biggest problems with shooting colour pictures is getting the interior colours right. Ambient lighting can be quite problematic, especially if there is a mixture of lighting types – tungsten, fluorescent and daylight. Professional photographers spend a lot of time trying to colour balance a scene with colour meters and gelatine CC filters. Although it is an advantage to try to get it right at the moment of capture, it is not as critical with digital media as it is with film. For cameras that don't have a RAW shooting mode the easiest way is to set the camera's white balance to the main lighting source – most digital cameras have several options to choose from. The other option is to create a custom white balance which involves taking a photograph of a white card. Most cameras will then automatically work out the correct colour balance. More sophisticated DSLR cameras also have a Kelvin scale which enables the photographer to match the colour temperature to the ambient light. The best method of all is to shoot the scene in RAW mode as this method captures all the image information and a custom colour correction can be applied on the computer at a later stage.

edit

Exposure for an interior should be metered in exactly the same way that you would with film photography, but there are times when a window looks out on a bright sunlit exterior throwing the exposure totally out. This is a very simple problem to correct without having to resort to placing large sheets of neutral density film over the offending windows.

The first picture (1) was exposed to give a correct exposure for the interior, but this has caused the exterior seen through the windows to almost totally burn

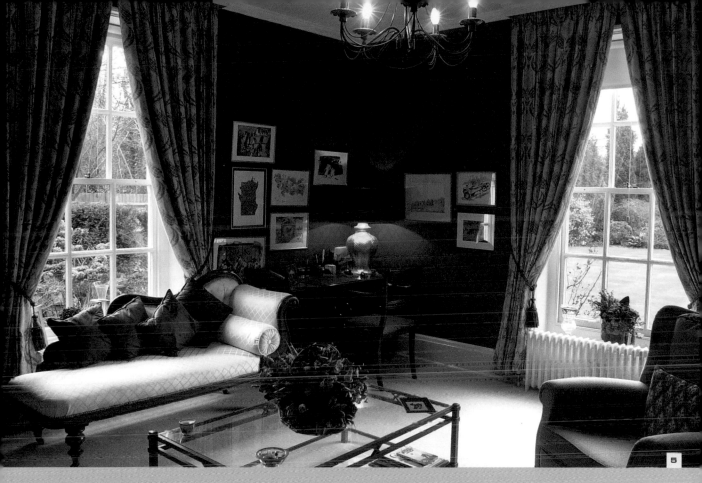

5

out. Detail in the window frames has also been lost.

The second exposure (2) was made for the exterior, resulting in a grossly underexposed interior. Several exposures were made to achieve the best detail in the window frame and for the exterior.

The interior exposure was dropped on top of the exterior photograph by simply dragging and dropping using the Move tool in Photoshop (3). Holding down the shift key during the drag and drop will ensure the two Layers sit exactly on top of each other.

A Layer Mask was added to the interior layer by clicking the Add Layer Mask Icon.

Click on the Layer Mask to make it active. (The background and foreground swatches will turn black and white, indicating that you are painting on the Alpha Channel.) Using the paint brush with black selected and paint on the mask to hide the overexposed windows (4). The bottom layer will be revealed as you paint in the black. To erase brushstrokes, switch to the white swatch and this acts as an eraser (press Ctrl + X to quickly switch between foreground and background colours). Subtle shading can be achieved by varying the brush opacity. A pressure sensitive graphics tablet makes this a simple exercise.

1/ 2/ The original alternative exposures.

3/ Adding a Layer Mask.

4/ Painting on the Alpha Channel Mask.

5/ The final image with balanced exposures between interior and exterior.

4 **alpha channel**

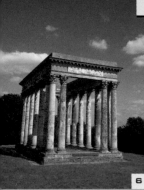

Convert the picture into a Layer by double clicking on the picture icon in the Layers palette. Create a new Layer and drag this Layer below the picture Layer. Highlight the new layer and then increase the canvas size by approximately 25 percent, (Menu > Image > Canvas Size), and make sure the bottom centre box is selected.

Fill this layer with white (Shift + F5). The canvas size has been increased to allow the image to be stretched upwards.

Highlight the top layer (the picture) and turn on the Grid. You may have to set your grid size and colour to suit your own image, this can be done via Edit > Preferences. From the Menu select Edit > Transform >

Distort. Now drag the corner handles to correct the distortions in the image, use the Grid to visually check the Horizontal and Verticals. Finally, drag the top centre handle upwards to give the building back its height and crop the image to remove the unwanted excess white canvas.

6

7 transform

8

This picture of the architectural folly had to be taken with a 20mm wide-angle lens to avoid a brick wall in the foreground. Using a wide-angle lens pointing slightly upwards introduced a pronounced perspective distortion. Pointing the camera straight-on cures the distortion but also includes the brick wall and the expanse of sky is lost. Here is a simple workaround that can be applied to almost any architecture picture.

! For your grid, select a contrasting colour to your overall image and make sure it has enough squares to line up your verticals without getting in the way of the overall picture.

! Most distortions can be corrected on the computer, make sure your canvas size is big enough to allow for stretching.

6/ The original capture with perspective distortion.

7/ Stretching the image over a bottom Layer of white canvas.

8/ The final cropped image.

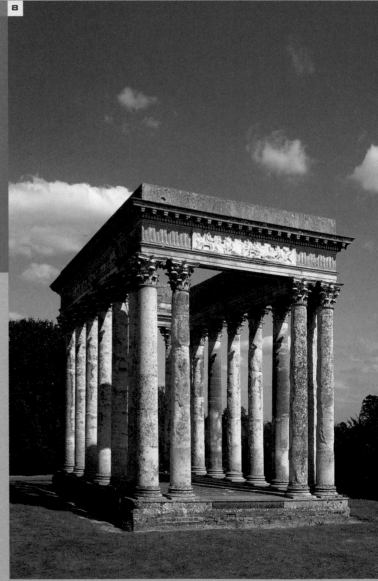

9/ This Phase One sliding digital back replaces the film holder on a 5 x 4inch camera and captures a 22Mp file (64MB). The picture is composed and focused using the viewfinder on the left. To take the picture, slide the digital back into the same position.

10/ The Sinar P camera will accept a medium-format size digital-film back allowing the architectural photographer to have full use of the rise and fall features on a view camera (although the 22Mp film back only has an equivalent film area of a medium format camera). To utilise the full 5 x 4inch coverage, a series of pictures can be taken and then stitched together. (See the Panoramas section in this book).

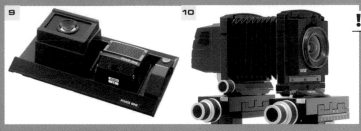

! Use a sturdy tripod with a good quality head and a cable release to ensure vibration-free pictures. This is particularly important if you are intending to merge two images.

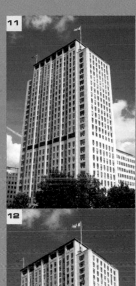

11/ This building was photographed with a 24mm lens on a Nikon D1. The building appears to be leaning backwards due to converging verticals.

12/ Using the Perspective crop feature in Photoshop, the building's perspective has been corrected but the tower has a distinctly 'squat' look about it.

13/ Using an increased canvas size and stretching the building upwards gives a more natural look

14/ Architecture photographer Michael Jones used a Phase One digital back on his Sinar 5 x 4inch camera to capture this early evening shot of Charing Cross station, London. Michael used a 210mm Nikkor lens, together with a long exposure – 40 seconds at f22, to give him the required depth of field. Although a deceptively simple picture, the shot took two hours to set-up and several cups of coffee whilst waiting for the perfect light.

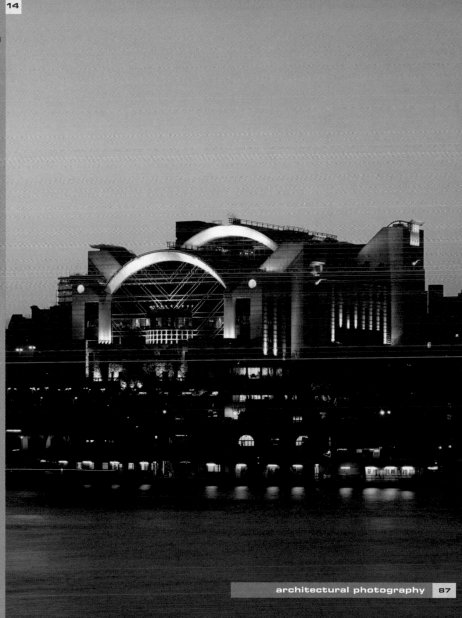

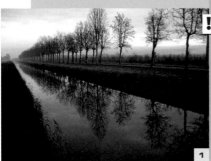

To capture the subtleties within a landscape you will need a high-resolution digital camera. A prosumer 11Mp camera, will out-perform most 35mm film cameras. Cameras with less mega pixels can capture the detail, but the lower resolution restricts the potential size of your print.

1/ Original capture.

2/ The final sepia-toned version.

3/ Removing the colour.

4/ The duotones palette.

5/ Customising duotone colours.

6/ Further finessing using Curves.

7/8/ Duplicating the background Layer, so that a gaussian blur can be applied to one of these.

landscape photography

Although the landscape is the most accessible of all subjects, it is also the most challenging. A dedicated landscape photographer may wait for hours, days or even weeks for the right conditions before taking the picture. This personal act of selection will be the difference between a good picture and a great photograph. Ansel Adams, a landscape master, used a large-format camera to capture every minute detail. One of the main advantages of large-format cameras is that the individual sheets of film can be developed according to the exposure. The disadvantage of using large-format cameras soon becomes apparent when you are climbing a steep hill with a large case and tripod. So having established how well-suited a large format camera is for landscape photography, where does the digital camera fit in?

capture

Landscape photography can be a very expressive form of image making. Although detail is generally considered to be very important it is not always imperiative. Look at some of the impressionist paintings and you will appreciate that there is more to a picture than being able to count the blades of grass. A good landscape image should capture the spirit of the landscape and draw the viewer into the scene. Agnoletti Alberto used a compact Canon camera to capture this striking canal scene. Agnoletti believes that to get the best digital photographs you still need to pay attention to composition, exposure and wait to for the best light. Without doubt, the best time to capture landscapes is early morning or evening. Midday sun can cause too many heavy shadows. This early dawn scene and the absence of people gives the picture an air of tranquillity.

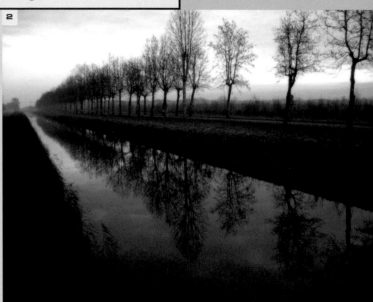

edit

After capturing the image Agnoletti decided at a later stage that he wanted to make it sepia-toned. Agnoletti could have used a variety of methods to achieve the effect he wanted but he decided to use the Duotones feature in Photoshop.

To achieve the same effect select – Image > Mode > Grayscale from the menu, and click OK to discard all the colour information (3), then select Image > Mode > Duotone.

On the Duotone Options palette (4) select Duotone (the other options are Monotone, Tritone and Quadtone). By default, the top ink is black and the bottom is white. Click on the bottom swatch and select a colour book. To select a colour scroll

down the list (5) or click the Picker button. If you have the Preview box selected then you can watch the image update itself. Click on the Curve icon next to the colour swatch and adjust the curve to suit your own image. You may have to adjust the black curve (6) to lighten up the overall image. Save your settings for use on other pictures.

B&W photographs evoke a mood and give a photograph an extra artistic dimension. Here we have demonstrated a few ways to convert a digital image to monochrome using an image by Agnoletti Alberto

Any of these methods will produce a greyscale picture. Methods 1 & 2 are far too basic for quality work. Method 3 is an interesting workaround, especially when you add some of the colour gradients. By far the best method is to use the Channel Mixer, which gives precise control on each of the RGB Channels. Make sure the Monochrome box is selected and move the sliders. This palette may seem confusing at first but the important thing to remember is to keep the total values of the RGB channels to 100 i.e. Red +40%, Green +80%, Blue −20%, or any other combination. Increase the values to above 100 and the image highlights burn out, lower them to under 100 and the overall image looks flat.

3 removing colour

Discard color information?

OK Cancel

☐ Don't show again

4 duotone options

Type: Duotone

Ink 1: Black
Ink 2: PANTONE 146 C
Ink 3:
Ink 4:

OK
Cancel
Load...
Save...
☑ Preview

Overprint Colors...

5 custom colours

Book: PANTONE® solid coated

PANTONE 141 C
PANTONE 142 C
PANTONE 143 C
PANTONE 144 C
PANTONE 145 C
PANTONE 146 C
PANTONE 147 C

OK
Cancel
Picker

L: 47
a: 22
b: 56

Type a color name to select it in the color list.

To add a romantic feel, duplicate the Background layer (press Ctrl +J) (7) and apply a Gaussian Blur to the top layer (8). Using the Opacity slider reduce the opacity so that enough detail shows through while leaving a mystical halo over the entire image.

6 curves

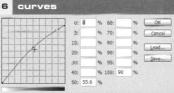

0: 0 % 60: %
5: % 70: %
10: % 80: %
20: % 90: %
30: % 95: %
40: % 100: 90 %
50: 55.6 %

OK
Cancel
Load...
Save...

7 duplicate layer

Normal Opacity: 50%

Lock: ☐ ☐ ☐ ☐ Fill: 100%

Layer 1

Background

8 gaussian blur

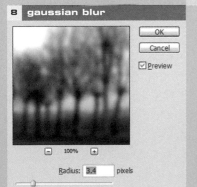

OK
Cancel
☑ Preview

100%

Radius: 3.4 pixels

Method 1: Use the keyboard shortcut Ctrl + Shift + U to quickly desaturate the colours.

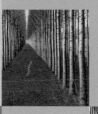

Method 2: Convert the image – Image > Mode > Greyscale.

Method 3: Make sure the Foreground and Background colours are set to their default setting and then apply a Gradient Map – Image > Adjustments > Gradient Map. Click on the gradient for further options.

Method 4: Use the Channel Mixer for greater control – Image > Adjustments > Channel Mixer.

2 colour picker

Select foreground color:

H: 37 ° L: 64
S: 75 % a: 23
B: 76 % b: 62
R: 193 C: 16 %
G: 137 M: 50 %
B: 49 Y: 100 %
 K: 1 %
C18931

☐ Only Web Colors

landscape effects

3 gradient editor

Presets

OK
Cancel
Load...
Save...

Name: Foreground to Transparent New

Gradient Type: Solid

Smoothness: 100 ▶ %

Stops

Opacity: ▶ % Location: % Delete
Color: ▶ Location: % Delete

graduated filters

Graduated filters are a firm favourite with landscape photographers as they can add a touch of colour to an otherwise dull-looking sky. A graduated neutral density filter will solve many extreme contrast problems within a scene. Graduated filters are rectangular in shape and are made with high-quality optical resin. The rectangular shape allows them to be positioned in a holder so that the colour section fits in with the image. A set of graduated filters can be very expensive but a photographer needs to purchase only one filter size, because with the right adaptor it will fit all lenses.

The problem with these filters is that the colour can cut through the top part of an image, so if you had a building in the scene then the top part would be coloured by the graduated filter.

Fortunately, using Photoshop or any application that uses Layers, you can simulate any filter, as a bonus you can accurately place the graduated colour at any point in the picture.

This shot of Aberaeron harbour in Wales was taken early in the morning and the sky was

uninspiring. The shot wasn't really worth taking without post-capture manipulation.

In Photoshop, add another layer above the Background Layer – the graduated filter will be placed on this new layer. Click on the Foreground colour swatch to open the Colour Picker palette and select a suitable colour (2), for this shot I chose a tobacco colour.

Select the Gradient Tool, then choose the linear gradient on the Options Toolbar and click on

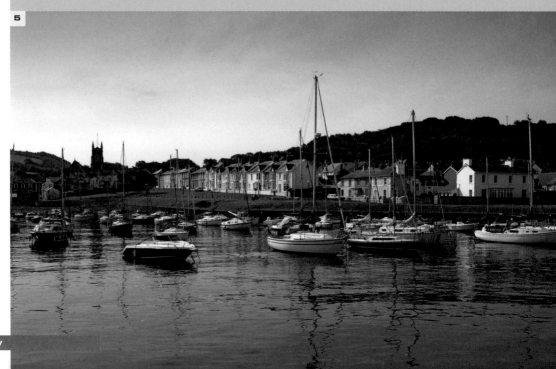

5

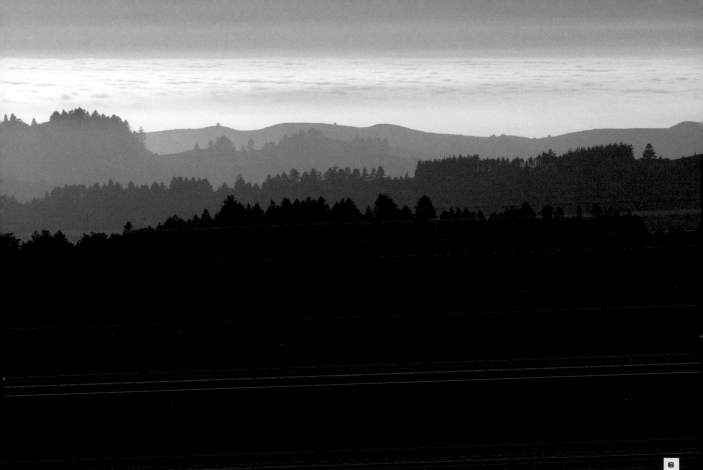

the Gradient swatch to edit it (3).
Select the second Gradient
preset – Foreground to
Transparent. This should
display your chosen colour
to transparent.

Using the Gradient Tool, draw a
line down from the sky and the
sky will take on the tobacco tint.
Set the Layers Blending mode
to Multiply (5) and lower the Fill
opacity to 90% or less. Apply the
same technique to create a
colour reflection in the water.
Make a new layer and this time
drag the Gradient up from the
base and set the blend mode to
Colour with a fill opacity of 20%.

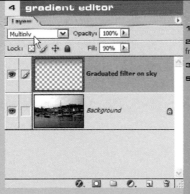

4 gradient editor

1/ The original capture.

2/ Selecting the filter colour
from the Colour Picker palette.

3/4/ Editing the colour gradient.

5/ The final image.

6/ 'Palo Alto' by Andrey Tverdokhleb. A
photographer based in San Francisco,
Andrey took this spectacular shot of a
mountain range at Palo Alto, California.
He used a Canon 10D camera fitted with
a 70–200 zoom lens set to 200mm at f8.
The photograph was taken in RAW mode,
but was too flat for Andrey's liking. He
converted the 16 bit image to 8 bit using
Adobe Camera RAW filter (this is now
included as standard with Photoshop CS).
The contrast was boosted by adjusting
the levels (Ctrl + L). The image colours
were boosted using Colorize in the
Hue/Saturation palette (Ctrl + U). Finally
Andrey applied some edge sharpening
to the image, using the Unsharp mask.
Sharpening the edges prevents the dark
areas picking up digital noise.

1/2/3/ The original captures.

4/ The frog with added contrast and a white background.

5/6/7/ Applying custom black and white points in Curves.

8/ Brightening highlights and darkening shadows in Curves.

9/ Using the Liquify filter to distort the frog's mouth.

10/ The finished image.

the digital studio

Working with digital equipment has simplified photography in the studio. With a high-resolution camera (11Mp or more) superb quality can be obtained. A digital camera will perform as well as, or even out-perform film. A photographer can now shoot a session with the camera tethered to a computer enabling instant viewing of the images as they are shot. This is a bonus for clients who want to attend a session, they can give approval by watching the monitor as the session progresses. Pictures are stored directly on to the computer as they are being shot. For expensive sessions a digital set-up totally eliminates any chance of disaster, short of hard drive failure.

Make no mistake, the equipment required is expensive, especially if you are using medium- or large-format cameras, the set-up costs can run into tens of thousands pounds. Fortunately almost all existing lighting and metering equipment can be utilised.

capture

Anita Dammer and Darwin Wiggett used a Canon EOS 1Ds with a 100mm f2.8 macro lens set to f16 for this humorous photograph of their pet frog 'Olive'. The lighting was provided by two lights placed at 45 degrees to one side and over the frog. One light was fitted with a large softbox and the other had an umbrella, giving the overall effect of a soft, wrap-around light.

edit

Using a very soft light source can leave the image looking flat so Photoshop CS was used to snap it up a bit (4). Next the b&w points were set using the Curves command. The black point was set to 13,13,13 and included the darkest part of the eye, the white point was the lightest part of the background (244, 244, 244). Setting these two points helped neutralize the magenta colour cast to the scan.

To apply custom black and white points, select Curves [Ctrl + M] and then click on the Options button (5). On the Options palette click on the white swatch (6) and then enter the required RGB figures (7), repeat the process for the black swatch.

Next the frog was selected using the quick mask tool and a relatively soft edge brush. Curves was selected again and a s-curve was applied to brighten the highlights and darken the shadows (8) that

! For composite pictures, try to keep the lighting set up similar, shadows going in every direction will detract from the overall image.

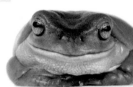

5 curves

Channel: RGB

Input:
Output:

☑ Prev

6 auto colour

Algorithms
○ Enhance Monochromatic Contrast
◉ Enhance Per Channel Contrast
○ Find Dark & Light Colors

☐ Snap Neutral Midtones

Target Colors & Clipping
Shadows: Clip: 0.10 %
Midtones:
Highlights: Clip: 0.10 %

☐ Save as defaults

7 colour picker

Select target highlight color:

OK
Cancel
Custom

◉ H: 0 ° ○ L: 96
○ S: 0 % ○ a: 0
○ B: 96 % ○ b: 0

○ R: 244 C: 3 %
○ G: 244 M: 2 %
○ B: 244 Y: 2 %
 K: 0 %

F4F4F4

☐ Only Web Colors

made the image more contrasty and saturated. The selection was then inverted so that only the white background was selected. Curves was used once more to set the darkest part of the white backdrop to pure white (255,255,255). This had the effect of a bright-coloured frog on pure white. Finally the picture area was extended above, below and to the right of the subject.

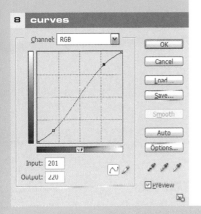

8 curves

Channel: RGB

OK
Cancel
Load...
Save...
Smooth
Auto
Options...

Input: 201
Output: 220

☑ Preview

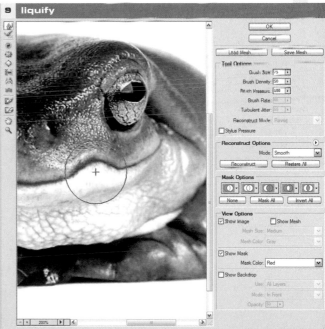

10

9 liquify

OK
Cancel
Load Mesh... Save Mesh...

Tool Options
Brush Size: 75
Brush Density: 50
Brush Pressure: 100
Brush Rate: 80
Turbulent Jitter: 50
Reconstruct Mode: Revert
☐ Stylus Pressure

Reconstruct Options
Mode: Smooth
Reconstruct Restore All

Mask Options
None Mask All Invert All

View Options
☑ Show Image ☐ Show Mesh
Mesh Size: Medium
Mesh Color: Gray

☑ Show Mask
Mask Color: Red

☐ Show Backdrop
Use: All Layers
Mode: In Front
Opacity: 50

- + 200% ▶ ◀

The other problem was the uneven highlights in the frog's eyes. Both eyes needed to look the same, so the left eye was selected (using quick mask), copied and pasted as a now I ayer, then flipped horizontally and dropped over the right eye. A little retouching work on the layer mask produced two matching eyes.

With the frog photographed, Anita thought it might be a good candidate for adding props. An icepack was photographed using the same lighting set-up and similar Curves Adjustments were made to match the icepack's tonal range to that of the frog. The icepack was placed on top of some green modelling clay to achieve the right shape and colour cast in

the shadow areas (2). The thermometer was taken from a stock picture of their son, also shot using similar lighting (3).

The thermometer was selected using the Quick Mask tool and pasted as a new I ayer on the frog picture. A Layer Mask was used to merge the thermometer into the frog's mouth. The Liquify filter in Photoshop was then used to warp the lips around the thermometer to add the final touch.

1/ The goldfish capture.

2/ The cat capture.

3/ Transforming the fish by scaling it to fit the final image.

4/ The final image.

! In a static set-up, the exposure settings can be controlled directly from the computer and the camera can also be fired from the keyboard. For moving subjects such as fashion shoots it may be better to use a memory card and transfer the images later; this also maintains the spontaneity in a session.

the digital studio II

capture

The cat and fish photograph Anita Dammer and Darwin Wiggett produced was an easier project.

The pet fish (a Celestine Goldfish named Mr. Fish) actually has these eyes, so no manipulation was necessary. The shot was a straight overhead shot using a Canon EOS 1Ds with a 100mm macro lens and two umbrellas to illuminate the scene (1).

The cat belonged to their neighbour and was borrowed for the afternoon (with permission). The cat was photographed separately to the goldfish, since putting the two together would be tempting fate. To keep the cat's interest, an empty bowl had some liver rubbed on to the rim and a small chunk dropped into the water (2). Whilst Darwin kept the cat in the right position Anita took a series of pictures with her Canon 1Ds. The cat was photographed slightly out of focus as the main attraction was going to be the Celestine Goldfish.

edit

For the final image Anita used the cat photo, cropped it tightly and then using Curves and levels, increased the contrast and colour saturation of the image. She used the Quick Mask to select the fish, then moved it to the cat photo. The Transform tool was used to reduce its size to fit in the bowl (3). To Transform a layer you can either select Edit > Transform >

Scale, or when using the Move tool check the Show Bounding box on the options toolbar. Finally, a layer mask was used to merge the two images, A soft-edge brush kept the Layer Mask from producing hard edges that give away the cut-and-paste nature of the photo.

! A 11Mp 35mm SLR-style digital camera will deliver results that are indistinguishable from a medium-format film camera.

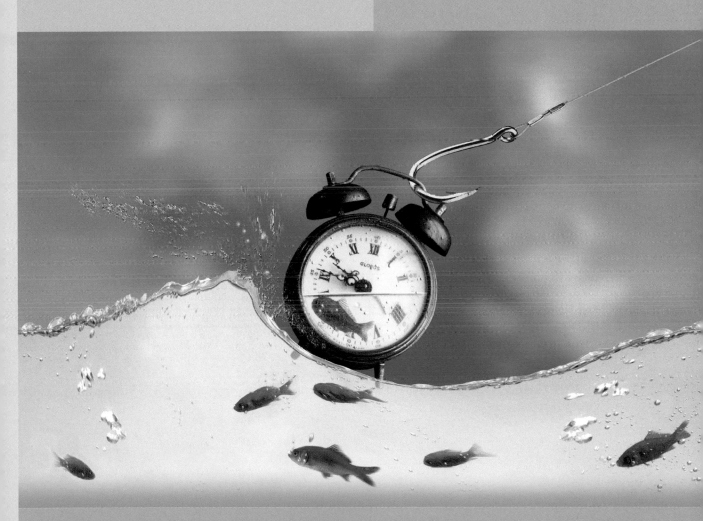

5/ 'Fresh Time' by Ciro Antinozzi. The studio offers an unlimited canvas for any creative person. The main requirements are imagination and patience to work out how to achieve the final result. Here,

several elements were photographed using a Digital SLR camera. Ciro combined these elements to make up his final picture. Pre-planning a picture is essential, although a rough sketch will often suffice. Ensuring

that the lighting is constant and coming from the same direction will simplify any retouching at a later stage.

! Create a comfortable relaxed atmosphere for your sitter – talk to them, ask them questions about themselves and show an interest in what they're saying. Build their confidence, compliment them on their eyes, their smile, their hair etc. Don't focus on any negative aspects (i.e. 'don't worry I can remove that spot in Photoshop'), be positive. Your subject will feel confident and relaxed.

! Be resourceful – look at what is available around you. In portrait photography, simple elements or details often work better than trying to get everything in. An interesting texture or corner of a wall can make a more suitable background than trying to include an entire scene. Try bringing your subject forward – this will throw the background out of focus and give your subject more prominence.

portraiture

A portrait is probably one of the most important documents that we possess, it's a visual statement of who we are – our identity captured in a split second. Portraits have many practical uses including ID cards, passports, publicity pictures and family records.

People either love or hate having their photograph taken, but why is this? Perhaps it is more to do with the nonsense that people put up with during the process of having a picture taken, do we all hate being told to smile at the camera, or manipulated into uncomfortable poses? Perhaps it's because people don't feel comfortable with the way they look or lack confidence in themselves. To get the best results from a person the photographer should make their sitter feel as relaxed as possible.

Whether using a digital or film camera the same photographic techniques apply. We still have to ensure that the lighting and the exposure are right, and that all the other technicalities for picture taking are correct. Assuming that the techniques are taken care of, we are left with the psychology of dealing with our sitter. This is the key to achieving a great portrait.

capture

We normally associate tender moments with the mother and child, in this photograph Chris Johnson captured a father with his son. The picture displays the strength of the man and yet at the same time his inner gentle nature – look at the eye contact between the two.

To further enhance the picture, Chris has converted the colour image into monochrome. 'All our pictures are shot in colour, we convert to Greyscale in Photoshop at the last stage. Although the client may ask for a b&w picture at the outset, it's surprising how many will ask for a colour shot at a later date.'

edit

There are several ways to convert to greyscale, from a simple Mode > Convert to Greyscale, to using the Channel Mixer. The method employed for this shot was by using three Adjustment Layers.

Once the image has been retouched for any imperfections, create a Hue/Saturation Adjustment layer by clicking on the Create New Adjustment Layer icon on the bottom of the Layer palette. Move the Saturation slider all the way down to –100%, this removes all the colour information (1). Observe the bottom colour ramp which should now be grey.

Highlight the Background image again and repeat the first step, this time don't do anything except click OK. Select the Hue/Saturation layer you have just created and change the Blending mode to Colour. Double click the Layer thumbnail (not the Layer Mask) and move the Hue slider to the desired tonality (2).

If the image is looking dull then create another Adjustment layer, this time select Curves and apply a gentle s-curve (3). Be careful not to block up the shadows or blow the highlights.

Save your picture as a Photoshop PSD file to keep the Adjustment Layers fully editable.

! Know your digital camera and all its features inside out before you use it on any session. The extra controls may seem daunting, but it's important to know what they do. Fumbling with your gear won't inspire your subject's confidence in you and will become an unwanted distraction.

! Watch out for obvious background distractions – poles and trees make unflattering headgear. Look out for objects with strong dominant colours as they will stand out on a print – your subject needs to be the main attraction.

! Wide apertures are not just for low-light photography, use a wide aperture for selective focusing. Use lens apertures to create a shallow or greater depth of field – a shallow depth of field can be flattering in a portrait.

1/ Removing saturation in first Adjustment Layer.

2/ Adding tonality.

3/ Adjusting Curves for added impact.

4/ 'Father and Child' by Chris Johnson.

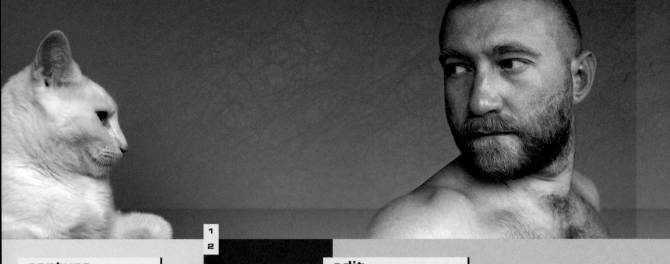

capture

Professional photographer and media designer Pavel Kaplun wanted to photograph his tomcat Vladimir, but the cat doesn't like having his picture taken, so Pavel had to stalk him with his Canon D60 to take a number of pictures. The shot used here was taken by available light and a small aperture (2). The picture was enhanced with a Curves Adjustment layer.

The self-portrait was easier, Pavel used a 28mm wide-angle lens and held the camera at arm's length to capture the picture of himself.

1/ 'Self-portrait with Vladimir' by Pavel Kaplun.

2/ The cat capture.

3/ The Layer Mask cuts out Pavel's head.

4/ A combination of masks and other elements were used to create the background.

edit

The self-portrait and Vladimir (3) were cut out using a Layer Mask. A new background was created in Photoshop using masks, gradient masks and other elements (4).

Pavel is fascinated by panoramic photographs and wanted to incorporate himself and his cat into one picture. The end result took six hours to complete.

3 layer mask

4 layers

5/ 'Bathtub' by David Pichevin. Digital photography opens up many possibilities, here, David has combined five photographs of his son in the bath to make up an unusual panoramic portrait.

6/ 'Family Feet' by Sarah Hines. Sarah took a small detail of a father and child's feet together and added a caption line using a decorative font.

! Fill your frame accurately before taking the picture. Your digital camera has millions of pixels available, don't just use a few of them. Take a pace nearer your subject or zoom in to make the best use of your camera's capture area. This will save you having to enlarge a portion of the picture which can result in loss of quality.

! Stop and look at what you are photographing and pre-visualise the picture before you bring the camera up to your eye. Although digital viewfinders are excellent, don't spend the entire session with your nose pushed up against the back of a camera. Check your picture on the LCD screen, this is the up-to-date version of instant photos.

5
6

! Clothing is very important. Ask your subject to wear something that will not distract or clash with the background. Simple colours or black and white, work better than anything else. Your subject should look and feel comfortable with what they are wearing.

! Shooting with a digital camera gives you instant feedback. Show your subject the preview, or if you have a Direct Print printer, then print out a picture – it only takes a couple of minutes and it's easier for you to check for mistakes (such as unwanted reflections, background or foreground distractions, undone buttons, faults in make-up). It's amazing how much more detail you will see in a hard copy print.

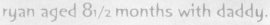

ryan aged 8½ months with daddy.

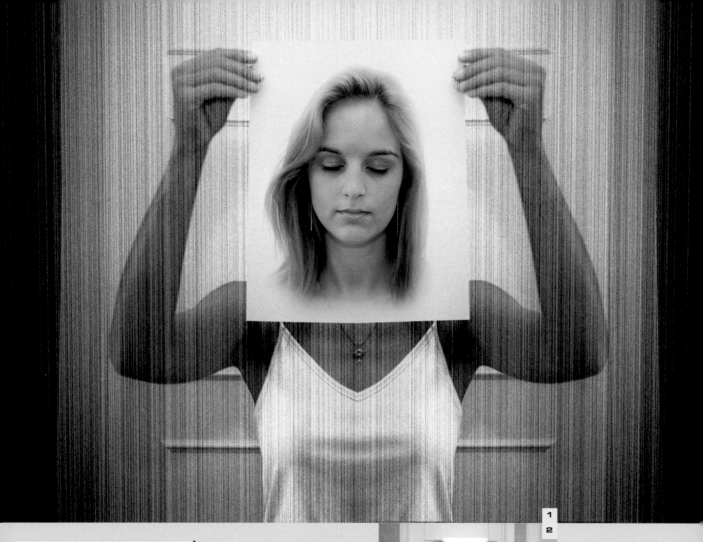

portrait montage

This shot by Ben Goossens was less complicated than it appears. The image was made up from two shots, the first was a picture of the model holding an A4 sheet of paper in front of her face. Ben used the Hue/Saturation set to Colorize and moved the Hue slider to obtain a blue. The second shot was a close-up portrait which was pasted as a new Layer.

The positioning and scaling of this shot was kept in proportion to the Background Layer. The eraser brush tidied up the excess areas around the head shot. Finally a texture was applied to the Background Layer. The manipulations on this picture took just a few minutes.

1/ 'Transparency' by Ben Goossens.

2/ The first capture.

3/ The close-up portrait capture.

4/ The original capture of Monica Sapek's daughter.

5/ The original capture of butterflies.

6/ Transforming the size of the butterfly to fit.

7/ 'Meadow' by Monica Sapek.

capture

Monica took this photograph of her daughter Kate in a meadow full of summer life (4). The light was glowing and Monica captured a memorable picture. As with all photographers – especially digital photographers – the picture is never complete unless it has been tweaked.

There was a second shot taken on the same day (5). Monica felt the butterfly would make an ideal addition to the picture of Kate.

edit

The Magnetic Lasso tool was used to select and copy the butterfly.

The butterfly was pasted twice on to the picture of Kate and using the Transform tool (Edit > Transform > Resize and Rotate) (6) the butterfly was scaled down and rotated. The second butterfly had a slight variation in rotation and scale.

The whole image was converted to Greyscale, then Duotone and a sepia colour was applied (7).

Watch how your subject moves. If they look uncomfortable ask them to move or do something else. Use your digital camera's playback feature to show them how they're looking – a professional model will spot an awkward pose and correct it. Let your subject find a comfortable position for themselves.

Stay honest with your pictures and don't over manipulate the image. Only use techniques that are going to add something to the picture or if you need to remove a distraction or blemish on your subject. Try to get as much right at the taking stage, saving time and effort later.

6 transform

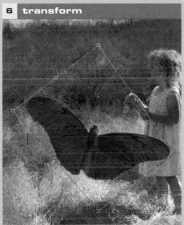

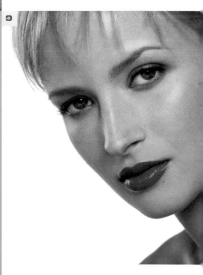

Great pictures are not just the product of the photographer but of the subject and photographer working together. If your subject suggests a pose then try it, don't dismiss their suggestions. They'll be pleased you're using their idea and will work harder to make it work. We can all learn something new from every session.

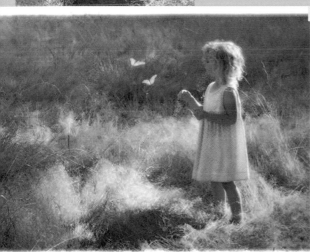

8/9/ New York photographer Kimberly Holcombe used a Light Phase H2O digital back on a Hasselblad camera for capturing this image directly to a computer. A tethered camera system lets the client view the session as it progresses and any adjustments can be made very quickly. Kimberly aims to get everything perfect during capture, this saves a lot of retouching time later. Smoothing out a few minor skin blemishes was all the retouching work needed for this beauty shot. Kimberly primarily shoots digital, but is happy to switch to film if a client requests it."

5 digital masters

'Untitled' by Todd Laffler.

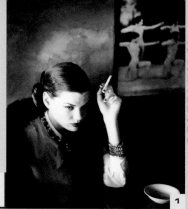

A Canon digital picture shot that formed part of a ten page editorial, taken at various locations in Florence, Italy. This shot was taken in a café with very low light that Nick loves. He uses very fast lenses (1.2 and 1.4) to capture the ambience. The b&w tonal qualities were manipulated in Photoshop.

1

nick scott

fashion photographer

Following a strong childhood interest in photography Nick Scott began his career as an assistant to a local wedding photographer. Winning a couple of national photographic competitions gave Nick the courage to go it alone as a professional. While working as a photographer with a theatre group touring Italy, Nick took the opportunity to show his portfolio to the art director of Italian 'Vogue' based in Milan. Commissions followed quickly and Nick's career in fashion photography was launched. Advertising work for TDK, Campari, IBM, Swatch, Nivea and others soon followed.

Nick moved back to London in 1993 and started on a new venture, shooting promotional videos for Max Factor, Vidal Sassoon and Oil of Olay. His video work has been televised in the UK and he was given a special mention at the Royal Television Society's regional awards. Today Nick has returned to still photography and is enthusiastic about working digitally. He also lectures for Adobe on After Effects.

More of Nick Scott's work can be seen at www.fashionflix.net/

2

4

2/ 'Treacy'

A picture commissioned by the Italian magazine 'Village' to show a series of Philip Treacy's hats. Nick used a 5 x 4inch Toyo monorail camera to capture this Polaroid shot. The image was scanned and extensively manipulated in Photoshop.

Model: Violetta Sanchez
Make-up: Topolino

3

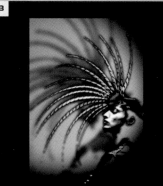

3/ 'Green Feathers'

The starting point for this stunning photograph is a frame from the video 'Philip Treacy – A fashion tribute', which Nick directed. The image was manipulated in Photoshop and After Effects. The shot took almost two days to work out and about an hour to achieve the final image.

4/ 'Moet'

This image began with another frame from the Philip Treacy documentary. This image was also heavily manipulated in After Effects, not the easiest application to get to grips with, but nevertheless an outstanding piece of software.

5

5/ 'Treacy'

A picture commissioned by Italian magazine 'Village' shot in London. Nick created a floating image by removing the model's body (in Photoshop). The surreal quality of the image ensures that the viewer will take a closer look at the wonderful hat by Philip Treacy.

Model: Violetta Sanchez
Make-up: Topolino

7

6

6/ 'Miele'

Backstage at any fashion show would seem like bedlam to the casual onlooker, but amongst all the noise, shouting, hairdryers and general panic, everyone knows where they have to be and what they are doing. Whilst creating a video of the London fashion show, Nick grabbed this shot with his Canon Ixus digital camera. The camera was set to a slow shutter speed with rear curtain sync., This combination produced a slight blurring effect that reflects the backstage mayhem.

7/ 'Debra'

Shot backstage at a Paris Haute Couture show with a Canon Ixus digital camera. This small camera is ideal for capturing spontaneous shots like this. The picture is also a personal favourite of Nick's.

Model – Debra Shaw

1/ 'Hippo with Waterlilies'

Although at first glance this seems to be a peaceful summer's day, it was actually a very dangerous encounter with a female hippo. Andy was up to his knees in the water at the time, the hippo became agitated and Andy had to make a dash for the car leaving the camera and tripod in the water. The unharmed camera was collected later that evening. Andy loves the way his digital SLR has picked up all the detail and retained the subtleties of the light. Taken with Canon EOS 1Ds and 300mm F4L IS lens.

2/ 'Charging White Rhino'

Luckily Andy was right next to the car (just in case a quick getaway was needed) and decided on this ultra tight portrait to enhance the feeling of danger. Taken with Canon EOS 1D and 300mm F4L lens.

Andy Rouse became a professional wildlife photographer in 1995. He has built an enviable reputation for his stunning images characterised by imaginative viewpoints and getting perilously close to dangerous mammals.

Andy has fully embraced digital photography, shooting everything on a **Canon 1Ds**. Shooting digitally allows Andy to quickly check his pictures before moving on therefore avoiding the temptation with film to shoot lots of rolls and see what you have later. No one wants to outstay their welcome when a herd of elephants is eyeing you up. Although Andy has a large collection of lenses from **28mm** through to **600mm**, his favourite lens is the **500mm**, this allows for a safe distance between him and the animal. All his pictures are captured on a **1GB** memory card and downloaded onto a **40GB** portable hard drive. The image files are transferred to a **PC** back at base.

Andy has appeared on numerous television programs including his own 'Wildlife Photographer' television series for the Discovery Channel, which continues to be broadcast throughout the world. Besides the usual photographic assignments, Andy is in constant demand to host courses and workshops as well as leading tours on foreign photographic expeditions. Andy Rouse is author of several books including the forthcoming 'The Essential Guide to Wildlife Photography' from AVA. He also supplies images to Getty picture library.

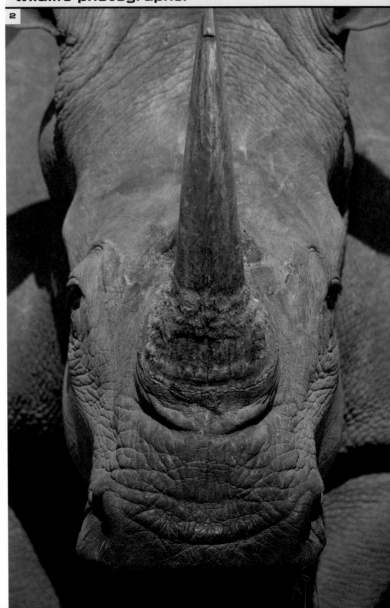

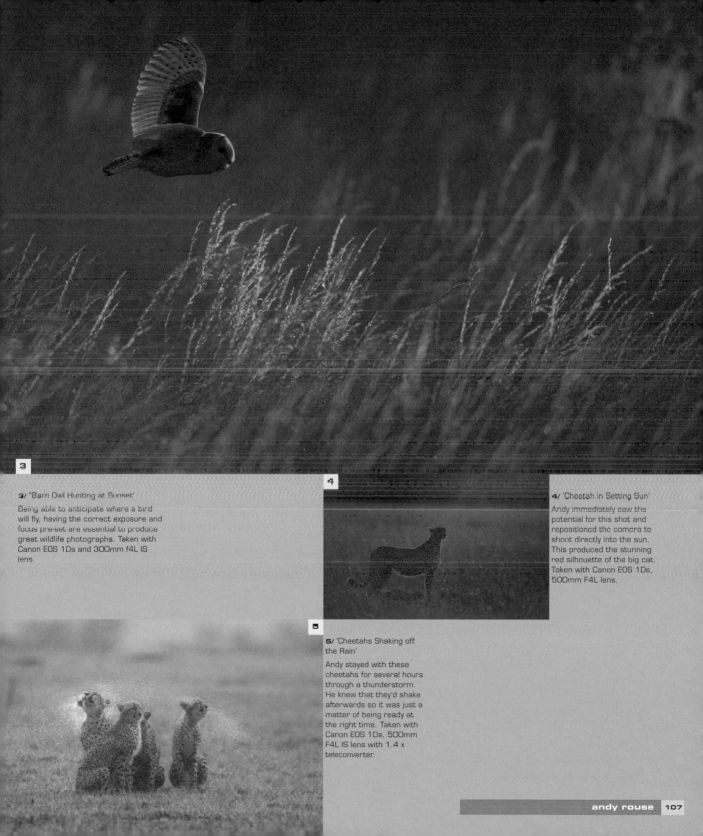

3/ "Barn Owl Hunting at Sunset"

Being able to anticipate where a bird will fly, having the correct exposure and focus pre-set are essential to produce great wildlife photographs. Taken with Canon EOS 1Ds and 300mm f4L IS lens.

4/ 'Cheetah in Setting Sun'

Andy immediately saw the potential for this shot and repositioned the camera to shoot directly into the sun. This produced the stunning red silhouette of the big cat. Taken with Canon EOS 1Ds, 500mm F4L lens.

5/ 'Cheetahs Shaking off the Rain'

Andy stayed with these cheetahs for several hours through a thunderstorm. He knew that they'd shake afterwards so it was just a matter of being ready at the right time. Taken with Canon EOS 1Ds, 500mm F4L IS lens with 1.4 x teleconverter.

john lund

stock photographer

John Lund has been shooting professionally since 1976. In 1990 he began to use Photoshop and Live Picture to manipulate images on his Macintosh computer. 'The computer is the most incredible creative tool given to a photographer, because it erases the barriers between imagination and creativity', he says.

John divides his time between shooting for stock, assignments, travel and shooting an image series featuring pets and other animals in human-like poses and situations. The amusing animal images are used for greeting cards, posters, calendars, jigsaw puzzles, and stationery. John finds bringing out the human qualities in animals is the most rewarding part of creating images: 'I often find myself laughing out loud as an image comes together.'

John's work has won numerous awards including: The Communication Arts Photography Annual, The Print Design Annual, Western Art Director's Club, PDN/PIX Digital, Micro Publishing News and Photo Metro. Both John and his work have been profiled in 'Professional Photographer', 'MacWorld', 'PDN', 'Mac Art and Design', 'Design Graphics', 'Photo Metro', 'Computer Artist', 'Shutterbug', 'Commercial Image', 'Photo Electronic Imaging', 'Commercial Printer' and 'Digital Imaging', amongst others.

John's conceptual stock photography is marketed through Stone, The Stock Market, Workbook Stock, The Stock Connection and his studio.

1/ 'Circuit City'

John describes the long process of creating ths image: 'I began with a series of straight-on 'copy' shots of several circuit boards and an aerial image of Houston shot in mid-morning. I inverted the aerial shot, which made it then look almost like a night shot. I then laboriously pasted in the circuit boards using free Transform and Distort. Transform gave them the perspective; size and placement and replaced the exterior walls of the buildings. In each case I added a Layer mask and faded-away the circuit board near the bases of the buildings. I created a network of clipping paths where the traffic patterns would be, then "stroked" the paths with airbrushes set to various opacities using orange, red and yellow colours. In the lower left of the image I pasted in some circuitry that had been silhouetted using Colour Range. Finally, I used Adjustment Layers to fine-tune the colour and saturation of the image.

2/ 'Woman Atlas'

'This was created to symbolize the plight of women who have to work and take care of the home', explains John. He placed the model's hands around an umbrella for the shot. He used the Pen tool to strip her out, then copied and pasted her image over one of clouds. A NASA shot of the earth was positioned behind the image of the model. 'I created a new Layer and used an airbrush to add some shadowing', he continues, 'the cloud Layer was duplicated and bought to the top of the Layer stack, before a Layer Mask was added. White was then used as the foreground colour.'

4/ 'Butterflies'

John says 'in this day and age information has become so abundant that we are becoming inundated with it! This image was created to symbolize that plethora of information and give us a glimpse into the next problem…dealing with it! I felt that by using a model wearing "safari" clothes I could create a timeless image. Using butterflies to symbolize information adds a whimsical and colourful element.'

Creating the image was fairly straightforward for John. He captured the model in his studio using the Canon 1Ds, and used a clipping path to create a selection (1 pixel feather), then he pasted that selection into a cloud image (shot on a Fuji Panorama Camera and Kodak E-100S). The sky wasn't quite interesting enough so he pasted in another sky with additional clouds, set the opacity to 80%, added a Layer Mask (hide-all) and then painted the new clouds back in as needed.

The butterflies were photographed with the Canon 1Ds (mounted butterflies purchased at a local art shop), then stripped-out using the 'extract' filter. Free Transform was used to rotate, size and position the butterflies. In some cases the Hue/Saturation control was manipulated to change the colours and also in some cases a slight Motion Blur filter was applied.

5/ 'Lighthouse'

'A combination of a California Lighthouse, New Mexico skies and the North sea were used to composite this image together. The lighthouse was silhouetted using a clipping path and pasted into the ocean shot. The sky could then be pasted in and a Layer Mask was used to softly merge the sky and the ocean by alternately painting black and white in the Layer Mask using a very large and soft brush. Adjustment Layers using colour balance and Curves were used to match the colours of the three images. After the image was flattened, a "beam-of-light" was created by making the appropriate selection with a clipping path, then Curves were used to adjust the brightness and contrast. It took quite a number of tries with various degrees of feathering before I found a solution that worked.'

3/ 'Break Out'

The model's shaved head and lack of clothing make this image timeless. John says the image was relatively simple to create: 'the model posed, miming pulling apart prison bars and screaming, in front of white seamless paper. The barcode was then shot in close-up.'

'I stripped out the barcode by creating a clipping path, then converted this to an unfeathered selection. Then I copied and pasted the barcode over the shot of the model. The Liquify filter "pushed" the bars apart to line up with her hands. I added a Layer Mask and with a small hard brush, used black as the foreground colour to "Paint-Away" the bars where they overlapped her hands to make appear as if she were grasping the bars. Voila!'

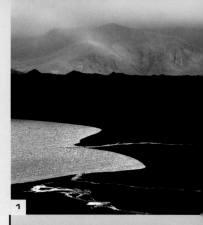

1/ 'Rainbow Lake'

'I had been driving in the rain for three days on a landscape shoot in Iceland' says Mike. 'Finally, the clouds cleared and as we drove round a bend on a mountain road we saw this rainbow appear over an almost black volcanic lava field and the light reflecting off the water in a shallow foreground lake.'

'The rainbow lasted just moments and then disappeared, but not before I had pulled the car over and managed to capture this frame.'

Mike shot the image with a Canon 1Ds fitted with a 70–200mmf/2.8L IS lens camera set to ISO 100.

1

michael reichmann

landscape photographer

Michael Reichmann has been a passionate photographer, educator and author for more than 30 years. He began his career as a photojournalist and then after some time in the IT and telecom industries returned to photography with landscape and wildlife as his primary focus.

His enthusiasm for the landscape radiates throughout his work. The secret of good landscape photography is to know your subject and at what time of day the light is going to be right for it. Michael will get up before dawn to position himself at the right location and wait for the day to unfold to get the picture.

Michael's work is a mixture of scanned film and digitally-captured images. Working with a digital camera gives him greater freedom and the ability to instantly check that all the elements in a picture are right. With some shots there is only a matter of minutes before the magical light has gone or perhaps a split second to capture a bird in flight — your camera must be able to deliver the goods when required.

Michael is based in Toronto, Canada, but travels the world taking photographs, lecturing and conducting field workshops. He is the publisher of 'The Luminous Landscape', a website devoted to landscape and photographic techniques. Michael's work has been featured in numerous books and exhibitions and can be found in private and public collections worldwide.

More of Michael's work can be seen at www.luminous-landscape.com

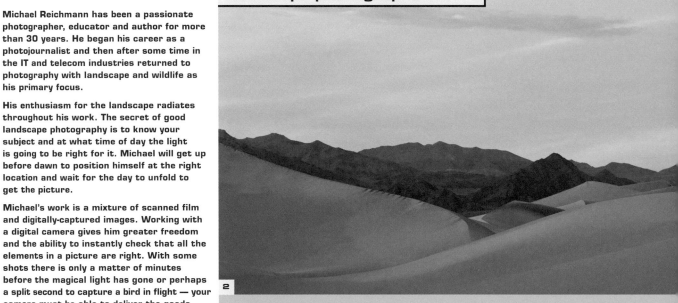

2

2/ 'Death Valley Dunes'

Photographing sand dunes in Death Valley, or anywhere in the world for that matter, is a delight. Light plays a vital role, and usually the strong shadows of either very early or late in the day brings out the texture and patterns best. However, on this occasion the soft light of a partially overcast afternoon produced an other-worldly effect.

The image was shot with a Canon 1Ds with 70–200mm f/2.8L IS lens camera set to ISO 100.

6/ 'Eclipsed Moon'

'I had read that the moon would rise in eclipse at sunset on the west coast of America on May 15th, 2003,' Mike recalls, 'I decided that Death Valley would be an ideal place to photograph this, due to the high probability of clear skies and the ability to use the sand dunes as foreground.'

'Weeks of planning paid off as this photograph shows – it reminds me of a fantasy illustration from the cover of a 1950s science fiction pulp magazine.'

3/ 'Clingman's Dome'

Mike had had a long, late afternoon standing on a hillside in Great Smokey National Park waiting for sunset that at first had proved disappointing. Clouds gathered on the horizon and the famous haze of this mountain area looked as if it would be obscured by the low-hanging clouds as well.

'My watch said that sunset was just minutes away' he says, 'yet there seemed little hope, so I turned, walked back to my car and started loading my photo gear. As I was almost done I heard a shout from someone behind me, "The sun, the sun!" I turned and there was an orange fireball emerging from a crack between the cloud layer and the distant mountains.

'I assembled my equipment as quickly as I could, ran back to the cliff and managed to capture one frame before the sun slid behind the distant peak.'

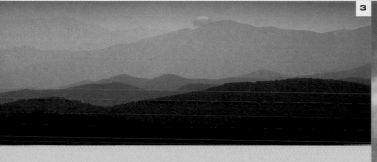

3

4/ 'Tumbleweed Dunes'

Mike remembers, 'Monument Valley is sacred to the Navajo people. But it is also a place with dramatic contrasts in the landscape. Our guide brought us to this location just as the sun was rising and the light was still soft, but highly directional.'

'The image evokes for me the starkness as well as the grandeur of the American southwest.'

4

5/ 'Cloud Swirl'

On arriving at Zion National Park the night before Mike was greeted by a snowstorm. The next morning dawned bright, but with high winds and swirling clouds. 'The clouds produced some of the most beautiful patterns that I had even seen or photographed', Mike says. The image was shot with a Canon 1Ds fitted with a 70-200mm f/2.8L IS lens camera set to ISO 100.

5

6

douglas kirkland

1

portrait photographer

Douglas Kirkland is without doubt one of the world's great portrait photographers. He has photographed most of the great Hollywood stars including Marilyn Monroe, Elizabeth Taylor, Robert Redford, Paul Newman, John Wayne and Kim Basinger amongst countless others. He has worked on over 100 movies from 'Butch Cassidy and the Sundance Kid', to 'Titanic' and 'Moulin Rouge'.

Douglas started his photographic career in the early 1950s using large-format plate cameras. He is full of enthusiasm for digital photography and is keen to experiment with new techniques. Today he shoots almost everything with a Canon EOS 1Ds digital camera or on a Mamiya 6 x 7inch film camera. Douglas's view is that there is more to taking pictures than having the latest state of the art equipment – it's about looking and knowing when all the picture elements are right before pressing the shutter button. The final result must be the priority, not the equipment.

Douglas has produced several books including; 'Light Years', 'Icons', 'Legends', 'Body Stories', 'Woza Africa', James Cameron's 'Titanic', and 'An Evening with Marilyn Monroe'.

More of Douglas's work can be seen on his website:
www.douglaskirkland.com

3

2/ 'Andy McDowell'

Photographed in New York for 'New York' magazine with a Canon EOS 1 N, fitted with a 35–135 zoom Ektachrome EPP film. The image was scanned in and the high-contrast poster effect created with Adobe Photoshop using Curves and digital painting. It was produced as part of a book called 'Icons' published by Harper Collins.

3/ 'Pierce Brosnan'

Photographed in Malibu for 'People' magazine with a Mamiya RZ 6 x 7inch, fitted 100–200 zoom and Ektachrome 100 Plus. The image was later scanned with Imacon 848 and converted to Greyscale in Adobe Photoshop.

4/ 'Bjork'

This was photographed in Florence, Italy for the Cinderella Ball with a Mamiya 6 x 7inch RZ and 100–200 zoom. Ektachrome 100 Plus film was used and a Dynalite 100 Strobe with a soft box.

4

5

5/ 'Moon Madness'

This nude shot was photographed in Kirkland's studio using Canon EOS1 N with Plus X b&w film. The background is an astronomy image from Kirkland's archives. The image was scanned in, colour was introduced and the finishing was done using Photoshop.

The foreground image is masked using a combination of the Magic Wand tool on the original b&w background plus a few touch ups with the Selection tool for refining. 'All very simple and straightforward, no special masking software was needed', says Kirkland.

judy mandolf

Judy Mandolf has exhibited her pictures throughout the US and in Europe. She has won numerous awards for her outstanding contribution to the art world, including 'International Photographers' Year and a Gold Medal Discovery Award by 'Art of California' magazine.

Judy moved over to computer-generated art in 1996, even though she trained as a traditional photographer and has owned a darkroom since the early 1980s. She is now totally digital and uses a variety of software applications ranging from Painter to Photoshop CS. The pictures are printed on high-quality textured fine art paper using an Epson 7600 large-format printer with UltraChrome inks. Some of her pictures are further enhanced with traditional media such as paints and pencils. 'I had images floating in my mind for years that I was unable to reproduce photographically', she says. 'I am so fascinated by the absolute freedom afforded by the digital medium to create my mindscapes.'

Judy still has ties with her darkroom days and prefers to simulate traditional darkroom effects such as dodging, burning, hand-tinting and sepia toning. This is view shared by many photographers who have moved over to digital.

Judy is represented by the Desurmont Gallery in Taos, the North Dakota Art Gallery Association, Bentley House in Walnut Creek, California, and William Torphy Fine Arts in El Sobrante, California. She lives in San Diego, USA.

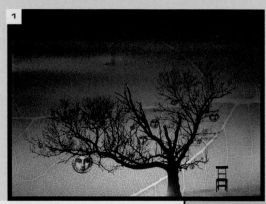

1/ 'Tree'

'A digital photo of a beautiful tree found in the San Diego mountains' says Judy. Extracted and collaged with a close-up photograph of a leaf along with an antique Irish chair. The face is part of a wall sculpture, scanned, pasted, duplicated and resized. The sunset image was added as a final Layer with the blending mode set to Multiply. A shadow under the chair was added with a soft brush at low opacity.

2/ 'Contemplate'

The background photo is of a fairly modern building from Judy's archives collaged with a sculpture which she photographed in Santa Fe, New Mexico. The 'window' was added to the door to add more interest. The spider's web was photographed in her garden against some flowers, with the background thrown out of focus. It was added as the final Layer, using a blend mode which emphasized the web and added colour to the otherwise monochromatic image. The intent was to add a feeling of mystery and antiquity to this stark architecture.

3/ 'Venetian Wall'

Encaustic collage inspired by Venice, Italy. A photo of a wall was torn in several pieces, dipped in hot wax and fused to a wood panel with a heat gun. The face was from a scanned tree ornament. An old skeleton key, coloured stones and twine were added, and the edges of the image were painted with hot wax mixed with black pigment.

4/ 'Pot of Gold'

Antiquity and ambiguity inspired by an old abbey in Gordes, France. A sculpture and a leaf collected on a walk were collaged. Flaming Pear's Melancholytron filter was added to create the glow, grain and darkened lower portion. The centre was dodged slightly and a golden Hue/Saturation was added, then blended with the merged image. Lastly, the outer edge was darkened using the Burn Tool, in Photoshop CS.

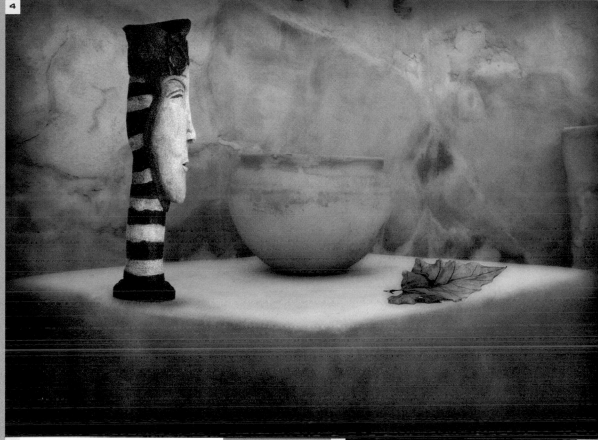

5/ 'Hanging Tulips'

Flowers are much more interesting when they are almost ready for the trash. These thirsty, drooping tulips have such grace. The flowers were suspended from a florist's ribbon tacked to a piece of mat board and photographed in natural, east window light. The image was totally desaturated in Photoshop and a slight sepia tone was added with an Adjustment Layer. Colour was added via an Adjustment Layer in varying opacities with the brush set to Colour.

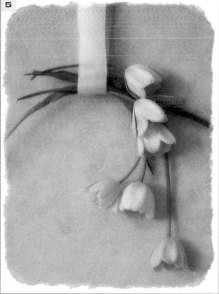

6/ 'Portals'

An encaustic collage inspired from photos and objects collected in Ravello, Italy. The photo of a wall was applied to a wood panel with hot wax and fused with a heat gun. Then a photo of a clock and a scan of a vintage postcard was dipped in wax and placed on top. Other objects added were a vintage door plate, some twine, sheet music, text and ancient coins. Gold leaf and an oil-painted 'cloud' was added afterwards. The edges were painted with wax mixed with black paint. The encaustic adds, luminosity, texture and depth.

heather mcfarland

Photography really took off for Heather after she purchased her first digital camera back in 1998. She now uses a Nikon D1X camera with a variety of lenses, her two favourites being the 80–200mm 2.8 Nikkor zoom and a 60mm Micro Nikkor. Heather tries to get out every day and shoots between 70–120 images in RAW format on a variety of subject matter. 'I shoot almost exclusively in RAW now for the flexibility it gives me over white balance and exposure control', she says.

Heather is particularly drawn to the graphical elements of colour and form in everyday objects and scenes. She has recently moved to a rural area in Northern Michigan, USA and has turned her camera on the surrounding landscape. She sells prints from her website and via art dealers.

Heather's visual style is both refreshing and stimulating. She embodies the true spirit of photography and her enthusiasm radiates throughout her work.

1/ 'Fog on the Farm'
Taken early in the morning, Heather saw the sun was just about to break through the clouds, so grabbed her camera and rushed out of her house to take this stunning picture. Her rapid reaction to an ever-changing scene paid off.

2

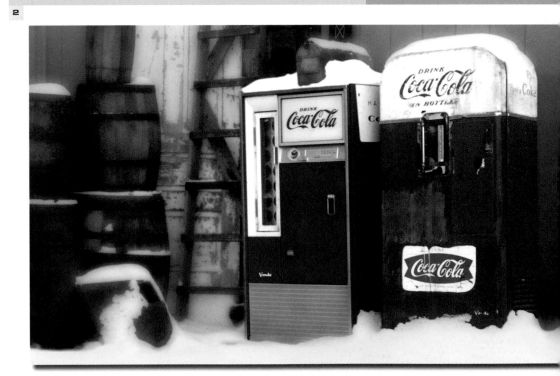

More of Heather's work can be seen on her website: www.hkmphotos.com

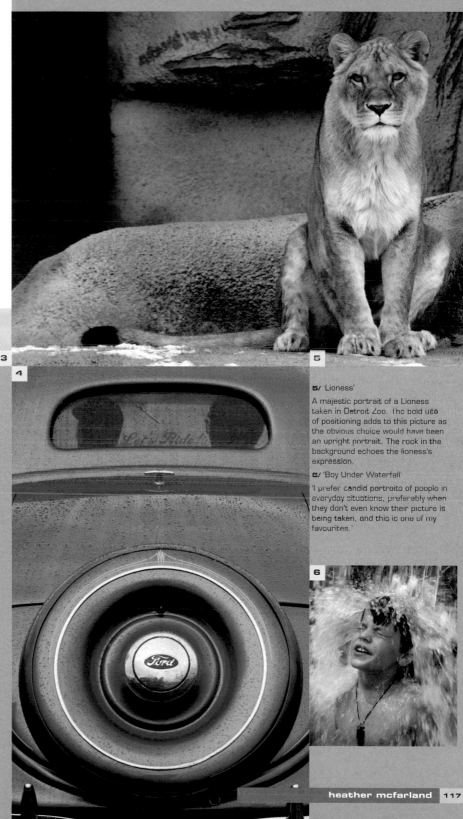

2/ 'Classic Coke'

Taken at an antiques shop near her home. Heather made the vending machines stand out by desaturating the background and adding a Gaussian Blur. The picture is not just a shot of two machines, it's a slice of iconic American history.

3/ 'Water Colours'

An effective yet simple idea, Heather stacked three vases filled with water and then added some food colouring. She had to work quickly before the colouring diluted too much.

4/ 'Ride in the Rain'

This shot was taken at a small gathering of classic car enthusiasts near Heather's home. 'Shortly after I arrived a downpour started and most of the car owners left as they don't like to get the cars wet or dirty. However, this beautiful blue car stayed with the owners sitting in it to escape the rain. I loved how the raindrops accented the beautiful paint and I was able to get in close from behind the car and capture the image. I really think the raindrops and even lighting combined to give this image much more character than if there had been no rain.'

5/ 'Lioness'

A majestic portrait of a Lioness taken in Detroit Zoo. The bold use of positioning adds to this picture as the obvious choice would have been an upright portrait. The rock in the background echoes the lioness's expression.

6/ 'Boy Under Waterfall'

'I prefer candid portraits of people in everyday situations, preferably when they don't even know their picture is being taken, and this is one of my favourites.'

6 digital presentation

'Muse Museum' by Ben Goossens

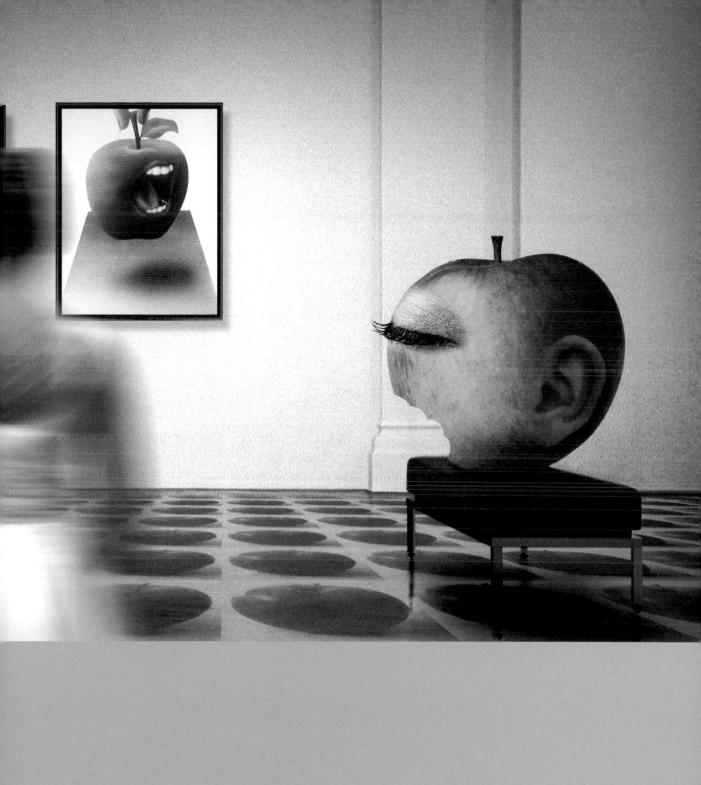

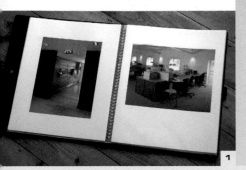

! Showing a portfolio does have the advantage of enabling you to meet an agency or client on a one-to-one basis. Unfortunately most of the time you will be asked to leave your valuable portfolio at the reception desk and pick it up another day.

the digital portfolio

An essential element for any photographer is the portfolio. A good collection of pictures can launch a photographer with a successful career whilst a mediocre collection will ensure that progress is slow.

I have seen so many photographers put together an outstanding collection of slides, all carefully mounted in custom mounts, only to have their worked viewed by an art director or buyer holding the sheet up to an overhead fluorescent tube. Carefully mounted prints get dropped and become dog-eared so on the face of it a portfolio doesn't seem like an ideal solution. The digital age has brought about many changes in the way we capture images, so by the same token we have to look at new methods of showing a portfolio of pictures.

There are a number of possibilities for showing work and you no longer have to physically take a large portfolio of pictures to an agency. You can upload images on to a website and forward a link to the site. Now anyone can view your portfolio at their own convenience and if they like what they see they will call you in to discuss their project in more detail.

The portfolio case is by no means redundant though, a collection of well-presented prints still has impact. The advantage a photographer now has is that they can update the portfolio very quickly using a photo-quality inkjet printer. Pictures up to A3 (or larger) can be placed in acetate sleeves, making a tailor-made collection for a specific job a reality.

ESTELLE KLAWITTER PHOTOGRAPHY

《 10 》 FASHION/BEAUTY PEOPLE/MOODS PUBLISHED INFORMATION CONTACT

content is everything

The content of a portfolio is probably the single most important reason why a photographer may or may not get the assignment. What makes one portfolio stand out from the others?

Too often inexperienced photographers try to show too much. A collection of 15 to 20 prints is more than sufficient any more than that and whoever is looking at the work will loose interest, unless the pictures are exceptional. Content is also important, a wide range of subject matters will do you no favours. Instead focus on one particular style or subject. A client who is commissioning car photography doesn't necessarily want to see wildlife shots taken in a Kenyan National Park, however good they are. What they will want to see is imaginative shots of cars, even if they are old cars. The client will be looking for someone who understands the difficulty in shooting their subject and who can come up with solutions. The bottom line is to do your research and show only pictures that are relevant.

The internet or world wide web offers photographers the opportunity to showcase their work to an international audience 24 hours a day. A site can be a simple page of pictures or a complex Flash content multimedia presentation. The key is to have a site that is easy to navigate with images that display quickly.

The simplest method is to create a standard HTML page (HyperText Mark-up Language). There are several applications for creating websites, most notably Macromedia Dreamweaver MX and Adobe GoLive CS. Both of these applications allow the page to be designed in a desktop publishing style, i.e. you place your pictures and text exactly where you want them to appear. The application then inserts all the code and blank spacing images to make your layout work on the web. Experienced web designers create web pages using hand-coded HTML, this is a laborious task, but produces pages that are quick to display and are easy to debug. Most companies will have a broadband connection so images should

download fairly quickly, but still aim to keep your image size as small as possible without sacrificing too much quality.

HTML pages tend to be static, and often require the viewer to click on a thumbnail image in order to see a magnified version. The other option is to create a web page using Macromedia Flash. This will enable you to create slideshows with transitions, all the viewer has to do is sit back and watch. This application supports animation, sound and even movies. The downside on Flash sites is that they tend to be slower to download, and animations are often overplayed. The novelty factor can wear thin with a client who is looking for a new photographer.

As with a portfolio, you should limit the amount of pictures on a website, usually to 15–20 images per category, as scrolling through page after page of pictures can be tiresome. Limit the categories to four maximum and try to keep them related (fashion, beauty, people,

personalities etc.). If you have more images to show, then consider building a second site, you don't want to add landscapes and travel at the end of a people-based portfolio. The last thing you want is for someone to visit your site and leave not knowing what your speciality is.

Photographer Estelle Klawitter uses three categories to order her images: fashion/beauty, people/moods and published. The images are displayed one at a time as a manually controlled slideshow (2). The interface is clean and uncluttered, which focuses the viewer's full attention on the images. Estelle also includes contact details and other information.

www.estelleklawitter.de

1/ The old-style portfolio.

2/ www.estelleklawitter.de

3/ www.bryanhelm.com For more information on Bryan Heim see page 122.

! Create a website for clients to instantly view your work. Keep your pages simple and easy to navigate. Your viewer should not have to search to find the pages you want to display.

! Avoid putting too much content on any single web page, as this will cause the page to download slowly. Ideally any page should not take any longer than 15 seconds to download.

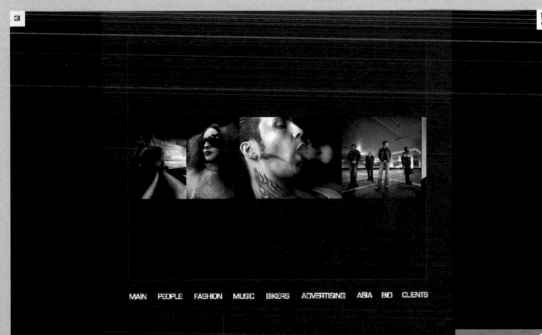

3

MAIN PEOPLE FASHION MUSIC BIKERS ADVERTISING ASIA BIO CLIENTS

Top Jazz photographer Jimmy Katz uses a stylish interface that compliments the subject matter he photographs (6/7). Good design is crucial for making a good impression. A website is your showcase and it must grab attention immediately.

www.jimmykatz.com

Bryan Helm shows his contemporary photographic style using a site created with Macromedia Flash (3). Far too often Flash is overused and displays more than the viewer wants, or has time, to see. Bryan has made an excellent compromise; the images in each category scroll through the window with the speed being governed by the cursor, click on any image and a rough preview is displayed (4) whilst the optimised image is loading (5). Bryan's website is visually attractive and would inspire confidence for anyone thinking of using his services. Of course having a collection of outstanding images also helps.

www.bryanhelm.com

Commercial photographer Ciro Antinozzi's website opens with a series of images accompanied by a saxophone melody (8). This lively introduction encourages you to enter the site, and the resulting images are nothing short of a visual treat. Ciro's site has six galleries: Publicity, Still Life, Fashion, Campaigns, Computer and Panoramas. Each gallery contains about ten images.

www.ciroantinozzi.com

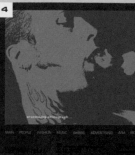

! Find a happy medium for JPEG compression; you want pictures to appear fast but you don't want poor quality.

! Many books still tell you to optimise your website for viewing on a 800 x 600 pixel resolution display, but most people are now using 1024 x 724 pixels. Don't dumb down your display for the few people who have not upgraded to a higher spec monitor, bigger is better.

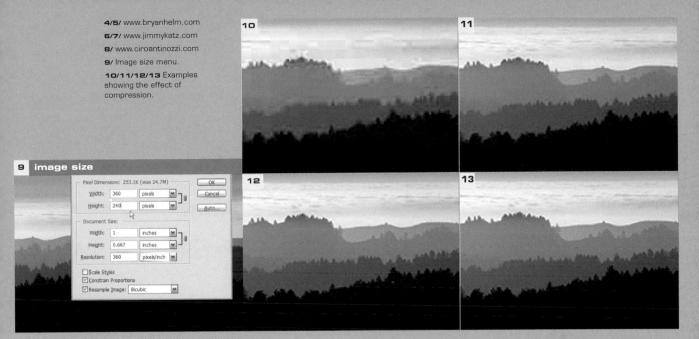

optimising images

Although most digital cameras will produce excellent quality pictures this is, to a large extent, wasted on images that are going to be displayed on a website. There has to be some sacrifice in quality in order to reduce the file down to a manageable size.

A 3Mp digital image will be approximately 9MB, which is far too large for displaying on the web. Pixels have to be discarded in order to reduce both the file and physical size of the image. To resize an image downwards select Image > Image Size and make sure the Resize Image and Constrain Proportions boxes are ticked then enter a new Pixel dimension in the top box (9). The sample picture by Andrey Tverdokhleb has been reduced from 3600 x 2400 pixels (24.7MB) to 360 x 240 pixels (253.1K). A 360 x 240 pixel image will be sufficient to fit most screen resolutions, but even

253K is too large for downloading. To get around this the image can be compressed by saving as a JPEG and then lowering the image quality by moving the quality slider to the left. The number can be interpreted as a quality level with 0 being the lowest quality. There is a preview button which will give a rough idea of what you can expect. On Andrey's photograph the quality has been reduced to give the following file sizes.

With compression set to 1–20.6K file on disk (10)

With compression set to 5–24K file on disk (11)

With compression set to 10–34.2K file on disk (12)

With compression set to 12–58.9K file on disk (13)

With compression set to 8–28K file on disk (14)

Lower settings will introduce severe JPEG artefacts, which will not be satisfactory for a photographer's website. The optimum for speed and file size would be somewhere around a compression of 8 – 28K on disk, this will ensure a small file with minimum artefacts.

! **Photoshop also has a Save for Web option, this allows you to preview images in different file formats; GIFF, JPEG or PNG and alter the quality levels on each.**

1 slideshow

Monitor layout

Monitor
DISPLAY1

Margins (in pixels)
Left/right: 10
Top/bottom: 10

☐ Clip image to fit the presentation area

[Background color]

Options

☐ Fast mode (don't use hires image)
☑ Change frames automatically
 Show each image for 4 seconds
☐ Continue from start after last frame
☐ Display logo
 File name:
 Alignment: Right Top
 ☐ The logo has a background color that should be transparent. Specify the transparency color
 [Transparency color]
☐ Show image text
 Template: File info Height: 100

Transition effect
Soft blend

[Save as movie] [Start] [Cancel]

2 quicktime movie

book 3 mov

File Edit View Favorites Window Help

3 PicturesToExe

2592x1944

<...> IMG_00... IMG_00... IMG_00... IMG_00...
IMG_00... IMG_00... IMG_00... IMG_00... IMG_00...
IMG_00... IMG_00... IMG_00... IMG_00... IMG_00...
IMG_00... IMG_00... IMG_00... IMG_00... IMG_00...
IMG_00... IMG_00... IMG_00... IMG_00... IMG_00...

☑ Show image O:\Guide to Digital Photography\Aldeburgh\100CANON\IMG_0005.JPG
Comment
Sound

[P] [Customize Slide...] [Object Editor...] Slide 5 of 100

[Create] [Preview] [Project Options] [Video] [Add] [Remove Slide] [Clear List]

alternatives

Although the web is probably the best solution for a photographer, there are a couple of other alternatives.

Create a CD with a slideshow of your portfolio (1/2). There are many software applications that will create a slideshow from a folder of pictures. Fotoware FotoStation Pro and Extensis Portfolio 7 both have the facility to create a QuickTime movie from a folder of pictures in a few minutes. These can be viewed on either PC or Mac via Apple QuickTime player.

Another excellent application is PicturesToExe (3), this creates an instant slideshow that will run on the windows platform and it will also create a movie, together with transitions and music, that can be saved to CD or DVD.

Ulead's Movie Factory 3 is another application that can be used to compile a sophisticated slideshow together with music and transitions (4/5). This can be used to write to DVDs for total versatility.

Sending a CD full of pictures doesn't guarantee that the recipient will actually view them – there are many viruses out there and big agencies are a prime target for hackers wanting to bring down a system.

1/ 2/ Create a CD with a slideshow played as a QuickTime movie.

3/ Create an instant slideshow to run on Windows.

4/ 5/ Use Ulead's Movie Factory to write to DVD.

! Keep limited editions to 25 prints maximum. To ensure the work will keep its value, don't over saturate the market with any one image.

! Clearly indicate how your limited edition works. Is the edition restricted to 25 prints at 15 x 12inch, or do you intend to start another edition of prints at 16 x 13inch? Generally, you should stick to one size and then move on to another image.

putting on the show

Photography opened up many possibilities for creative-minded people to produce innovative and striking images. At the start of this book I stated that photography has established itself as an legitimate art form. Today, with the advent of digital capture and reproduction, the artistic photographer does face certain obstacles in that people are still not sure about the value of a digital print or whether it will last. Silver Halide prints are a tried and tested traditional medium which people invest in with confidence. Inkjet material is every bit as stable and in many cases will outlast traditional media, but there are a few points a photographer must be aware of.

media

One of the biggest problems for ink media is gas fade, this one factor alone accounts for almost all image destruction. Gas fade is caused by inks coming into contact with atmospheric pollutants. When a drop of ink is fired at the media it is soaked up into the microscopic pores of the actual coating, rather like a sponge. The media pores never close and as such leave themselves open for any other pollutants to enter. These will eat away at the delicate dyes and over a period of time will destroy the colours. A way to avoid this problem is to encapsulate the print by sealing it behind glass. Framing is easy and it will give the print an extended life. This fade problem is not exclusive to inkjet prints, many great works of art have suffered through atmospheric pollutants.

Presentation of any picture is crucial for exhibiting. Your print must be seen to have value, people will look more intently at

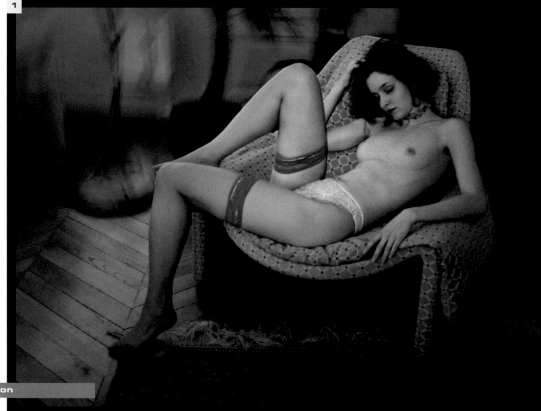

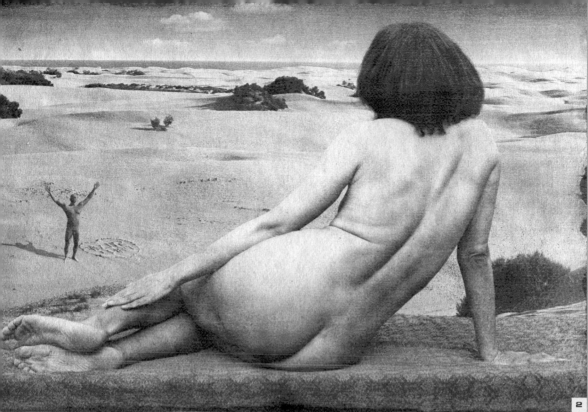

1/ 'Day Dreams' by John Peristiany. Fine Art photographs are enjoying an upsurge in popularity and collectors are seeking new talent with a progressive vision. This photograph by John Peristiany is a beautifully composed picture which relies on shape and texture. This image is likely to appeal more to a collector than to the person who wants to display it in their living room.

2/ 'Once Upon A Time on the Sea' by Dieter Frangenberg. Digital imaging has broken down the barriers between photographs and traditional works of art. It also opens up many possibilities for the creative-minded person as elements can be added or taken away from almost any image. What was once thought impossible is now well within the reach for those who want to explore the depths of their imaging application. This creative freedom has resulted in many new styles of pictures, from the complicated montage through to this beautifully controlled tonal range.

a picture that is well presented. Try this simple experiment; show a small 6 x 4inch picture to a friend and then show another 6 x 4inch print that has a large matt mount and is framed. They will look more carefully at the framed picture, because the work now has a perceived value.

There are many media surfaces available ranging from glossy through to heavy, textured art paper. Most of the time the media is chosen by the photographer to suit a particular picture. Consideration should also be made for the viewing conditions.

Metamerism is the effect of colours changing under different lighting conditions. This generally shows itself in the grey areas of a monochrome picture. It is very difficult to control but one solution would be to create prints that are balanced for viewing under similar lighting conditions as the gallery.

authentication

A person who is buying one of your prints will want to be assured that the limited edition of 25 is an edition of 25 prints only. You should offer a certificate of authenticity – the content of the certificate could be a declaration of your integrity, the authenticity of the work and a description of the media used. It should be signed and presented with the print on sale. Other useful information would be some advice on how to display the picture and what to avoid. For example; 'this print could suffer irreparable damage if displayed in bright sunlight or humid conditions.'

3/ 'Lancashire Marshes at Dawn' by Martin Woods. This early morning landscape scene has many excellent qualities and will appeal to a wide audience. Landscapes are popular (especially if they were shot by Ansel Adams), but they need to be spectacular to fetch a high price.

4/ 'Marcel Marceau' by Vincent Oliver. The National Portrait Gallery in London is amongst many galleries worldwide who do not have a problem exhibiting photography. The Royal Academy now also accepts photography for their annual Summer Exhibition. This photograph of Marcel Marceau was the very first photograph to have been accepted by the Royal Academy for inclusion in their Summer Exhibition.

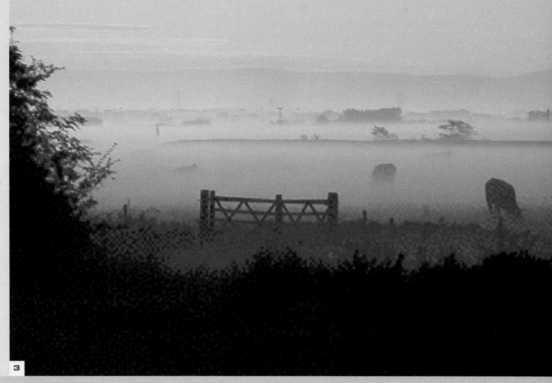

3

numbered editions

! If you want to produce prints for selling in large quantities then consider doing a signed edition without numbering.

! Pigment inks are going to give a longer print life than dye inks. You don't want customers returning after one year complaining about print fade.

You may decide to offer an edition of 20 prints. Do not offer all 20 in one exhibition, instead offer just five prints. The reasoning behind this is that if you set the initial price at £200 per print and sell all five, then the next time you exhibit you can offer the next set of five at £250 and so on. If you have sold 15 prints then this would indicate you have a winning shot, the last five prints can then be sold at any price you

think they will sell for. What has this achieved? You have made £3750 from fifteen prints, plus whatever price you set for the last five. Your initial customers will have seen their investment increase in value and for the last five prints you will have created a demand since it will be the last chance for a customer to purchase this particular work.

The temptation may be to increase the edition and make more money. It doesn't quite

work like that, human nature is always for us to want something we can't have – if there are too many then the demand will decrease. A better option is to produce another picture and start all over again. Of course, if you are selling all the prints at each exhibition then this would indicate that maybe you should start the edition at a higher price.

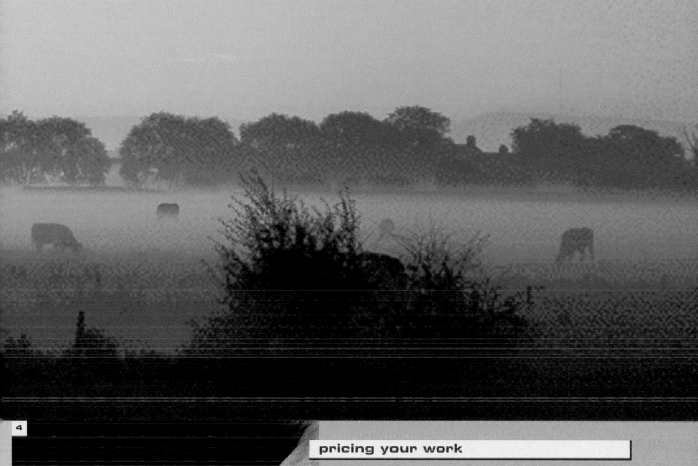

4

pricing your work

You can make a random choice, but if you've considered the time and effort involved in the image's creation, then you will always be able to justify the price tag. How long did the picture take to capture, did you have to wait for two weeks or longer before the light was right? How much expense was involved in shooting the picture (hotel, travel etc)?

How much time did you spend manipulating on screen? How many sheets of media did you use for the final result? Once all these figure have been worked out then you should add in a sum for yourself and the taxman. Use the assumption that you may only sell half of the edition and you begin to have a reasonable idea of the price.

adding value to your work

Putting on an exhibition is your showcase so people must know about it. Send out press releases to the local relevant media, the release should include a couple or more of the images that are to be included in the exhibition. Potential customers like to be reassured that the photographer they are investing in has a following, especially in the media. Generate as much publicity for the exhibition as possible, papers are always looking for material to fill their pages and this kind of publicity is free. You can, of course, also pay to advertise the exhibition.

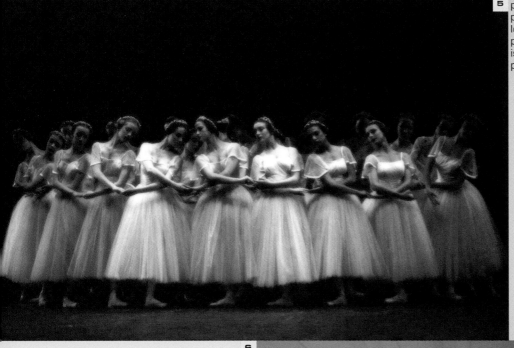

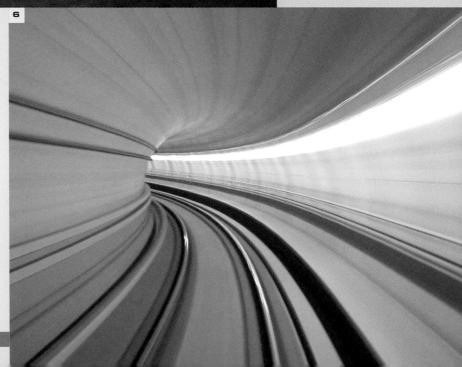

5/ 'Ballet' by Vincent Oliver. Photographs depicting other art forms are popular, Degas made a good living from producing paintings of the ballet. This photograph is popular with collectors and has almost sold out.

6/ 'Metro' by Willem Dijkstra. This unusual shot of the Copenhagen Metro by Willem Dijkstra may not be suitable for the average household, but dealers are also looking for art that they can sell to large corporations. A shot like this would look superb in any board or conference room, hi-tech shots such as this are therefore in constant demand.

7

think lateral

If you just want to exhibit your work rather than selling it, then consider other venues to the traditional gallery.

Several years ago I rented all the advertising space on an underground train and mounted the exhibition in the advertising slots. I had approached London Transport with my idea and they had the vision to go along with it. I secured the entire train at a minimal cost. This exhibition was seen by approximately 2500 people every hour for a period of one month. It created national interest in the press, radio and television. The exhibition was vandalised within two weeks, which created further publicity. The reason for telling you all this is that with imagination you can bring art to the masses, as they see it on their way to work or in the shopping mall. Your name in the press will of course make it easier for you to exhibit in galleries and so sell your work.

7/ 'Staiths' by Miguel Lasa. The versatility of digital manipulation means that you can produce an image that almost looks like a painting, short of the actual paint. However, it may be some time before a collector would consider investing in a digital image of this type. The techniques are just too new for the mainstream to see work so obviously using them as investment opportunities. However, for people who are seeking a long-term investment, then pictures like this one by Miguel Lasa might be a good choice. It is only a matter of time before images like this will be widely accepted.

! Use the best quality inks and media available for production.

! Include guidelines for buyers on how to maximise their print's life; for example warn about displaying prints in direct sunlight.

appendix

'Rome1' by Theo Berends

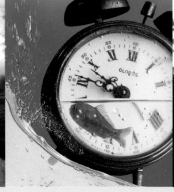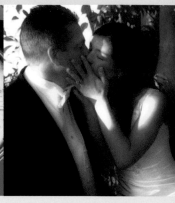

contacts

Agnoletti Alberto is an enthusiastic amateur photographer based in Italy. He loves using digital cameras mainly because he can view the images immediately, and it's always reassuring to know you have the right picture before moving on to the next shot. Agnoletti uses a Canon S30 digital camera.

pages 88–89

www.usefilm.com/photographer/14669.html

Ciro Antinozzi is a leading Italian professional photographer who has worked on many major accounts including those of Saatchi & Saatchi, Leo Burnett and other major advertising agencies. Ciro's interest in photography montage began in the early 1980s. By the early 1990s Ciro discovered the power of the computer and hasn't looked back since.

pages 95, covers

www.ciroantinozzi.com

David Beckstead lives in a small town in Arizona, USA. His passion for a creative approach to his photography has grown into a national and international wedding photography business. David uses two Nikon D1X's with three Nikon zoom lenses; 17–35mm f2.8, 35–70mm f2.8, 70–200mm f2.8 and a 50mm f1.4 lens.

pages 82–83

www.davidbeckstead.com

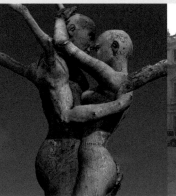

Sue Flood is a professional wildlife photographer working with the BBC Natural History Unit. This incredible photograph of the Great White Shark was photographed with a Canon S50 compact digital camera in custom-built underwater housing. Sue's photographs are placed with the Nature Picture Library.

pages 4–5

www.naturepl.com

Dieter Frangenberg is a digital artist based in Düsseldorf, Germany who likes to work in both digital (Canon D60) and film (Mamiya). Dieter uses a variety of software applications including Photoshop, Painter, Poser 4 and Cinema 4D – 'We are One' took over two weeks to produce.

pages 75, 127

d.frang@t-online.de

Hugh Gilbert is a London-based professional photographer who specialises in panoramic photographs. Hugh likes the immediacy that the digital format offers. Although the downside is that there is far more post production work to do. Hugh uses a Nikon D1X and a Spheron camera, the best of its kind, it is capable of taking a photograph that is 180 degrees by 360 degrees.

page 63

www.360.eu.com

Patricia Gooden was born in Minneapolis, Minnesota and currently lives in Florida USA. Patricia began to explore using the computer as an artistic tool in 1997, and quickly realised the potential this offered her. Today she uses the computer almost exclusively and outputs all of her work on an Epson pigment ink printer. Her images are captured on an Olympus E20-N digital camera or by directly scanning objects.

pages 60–61, 78–79

www.goodenart.com

Theo Berends describes his work in his own words: 'I photograph on the basis of emotion. The ideas for many of my photographs arise on the spot or during a session. More often than not, a shot entails only the beginning of a process. I linger on what I felt during the shooting…about the backgrounds or the history of the subject.'

pages 132-133, 138, 141

www.theo-berends-fotografie.nl

Hans Claesson was born on a tiny island just off the west coast of Sweden. He sees photography as a medium to make the viewer feel and think – a real challenge both for the artist and the audience. He often uses nature for inspiration, but tries to explore the human and photographic world as much as possible in many different areas.

pages 20, 57

www.go.to/photonart

Marlene DeGrood is based in Arizona, USA. Marlene is a professional photographer and enjoys the challenge of digital photography, which she believes has given more control to the photographer. 'The only restrictions lie in your own imagination and your knowledge of the tools needed to create the image.' Marlene uses an Olympus E10 for her photography.

pages 70–71

www.thedigitalspectrum.com

Willem Dijkstra is a digital enthusiast based in Hoersholm, Denmark. Like so many other photographers Willem enjoys the freedom a digital camera offers. 'The ability to experiment whilst at the location is invaluable for the development of new ideas.' Willem uses a Sony DSC-F707 camera for his photography.

pages 23, 130

willem.dpcprints.com

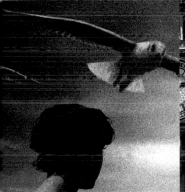

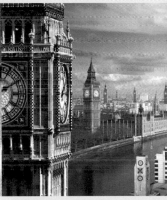

Ben Goossens worked for more than 35 years as an art director in a Belgian advertising agency. Ben creates experimental/surrealistic compositions, by combining photos and (airbrush) illustrations. All Ben's images are taken with a Nikon F80, or HP digital camera, scanned in, and manipulated with Photoshop, Painter and Fractal Design Poser on a Mac G4.

pages 36–37, 100, 118–119

www.photo.net/photodb/folder?folder_id=209032

Kevin Griffin is a leading advertising photographer based in Ireland who has worked on many major international accounts including; Eurostar, SNFC, Cable and Wireless, Peugeot, VW, Renault, Nissan, Volvo, Audi and Guinness amongst others.

pages 50–51

www.kevingriffinphoto.com

Sarah Hines is the studio manager for the 'Image Studio', a busy portrait studio in Kent, UK. Sarah has been involved with digital photography for more than five years, and states that 'although there is more work to do with the images now, we have full control on all aspects of a shoot and final look of the image'. Sarah loves photographing people with her Canon 10D.

page 99

www.theimagestudio-uk.com

Kimberly Holcombe is professional photographer based in New York, USA. Kimberly works almost exclusively with digital cameras. She uses a Hasselblad fitted with a Phase One H2O back, but will happily switch to film if a client requests it. Kimberly aims to get everything perfect at the taking stage, reducing the amount of time a photographer has to spend in front of a computer.

page 101

www.kimberlyphoto.com

Chris Johnson runs a successful portrait studio in the UK. Chris was early adoptor of digital cameras and stopped using film in 2000. He notes that 'setting up a digital workflow took us time, but once up and running it works to our advantage.' Chris uses a Nikon D1X and Fuji S2 Pro digital cameras.

page 97

www.theimagestudio-uk.com

Michael Jones is based in London, UK. He has been a professional architectural photographer for 25 years. His work ranges from photographing commercial offices to private show homes and stock library work. Michael offers his clients both digital and film images. He also supplies stock photographs to the Alamy picture library.

page 87

www.mike-jones.com

Pavel Kaplun combines graphical/design art with a camera and Photoshop. Pavel claims to be a Photoshop anorak and has worked with digital composting since 1999. Pavel creates surrealistic works and tries to make them as realistic as possible. Pavel uses a Canon D60 digital camera

pages 53, 98

www.kaplun.de

Todd Laffler is a professional photographer based in New Jersey, USA. When asked what is the draw to digital photography Todd replied 'the immediacy of digital is its lure for me. I'm not afraid of wasting "shots" and am able to experiment more freely. I also I love the control it gives me.'

pages 44–45, 102–103

www.toddlaffler.com

John Peristiany started photography at an early age, and what then began as a passion soon developed into an obsession. When he discovered the world of digital manipulation, it then became a compulsive pastime. John says; 'photography is a way of personalising the world in which we live.'

page 126

peristiany@hotmail.com

David Pichevin is a systems engineer based in France. David started photography as a hobby at the end of 2001 and has been obsessed with it ever since. David is one of the new generation of photographers who has never owned or used a film camera. He has used several digital cameras from a simple 'point and shoot' through to the latest Canon DSLR camera.

pages 62–63, 64–65, 99

www.pichevinphoto.com

Monika Sapek lives and works in Redwood WA, USA. She is enthusiastic about her digital photography, but also harsh on the shots that don't meet her own high standards. Monika advises; 'Develop a good digital workflow, this has become as important as composition and a good exposure technique.'

page 101

http://monika.sapek.com

Nick Scott is a professional fashion photographer who also creates promotional videos. His clients inlcude TDK, Campari, IBM, Swatch, Nivea and many others.

page 76–77

www.fashionflix.net/

Miguel Lasa is a digital artist based in Hartlepool, UK. Miguel shoots everything with a Canon 10D digital camera with a view to altering it in Photoshop at a later stage. Miguel uses plug-in filters extensively to create artistic effects, his favourite filters are autofx dreamsuite, mystical lighting and toning amongst others.

page 131

miguel-lasa.smugmug.com

Heather McFarland is an enthusiastic amateur photographer living in Michigan, USA. Heather got her first digital camera in 1998. The instant feedback and ability to control all aspects of image editing were very appealing. Heather uses a Nikon D1X digital SLR camera with a variety of lenses including; 35–70mm f2.8 and 60mm macro Nikkor lenses.

pages 10–11, 24–25, 116–117

www.hkmphotos.com

Jean-Sébastien Monzani lives and works in Switzerland as a Research assistant. Jean-Sébastien took up photography in 1998 and by 2001 had developed a keen interest in portraits. He advises; 'pay attention to the subject, the light and crucially the exposure. Research your subject in advance and explore all the permutations.'

pages 6–7, 58–59

www.simplemoment.com

Vincent Oliver has been a professional photographer for 25 years. His photographic work has been varied with much of it based in the television industry. Vincent has manipulated his images using a variety of applications.

pages 12–13, 18–19, 22, 28–29, 32, 38–39, 40–41, 42–43, 46–47, 48–49, 54–55, 64–65, 66–67, 68–69, 72–73, 75, 80–81, 84–85, 90, 129, 138

www.photo-i.co.uk

Andrey Tverdokhleb is a self confessed digital enthusiast who is based in San Francisco, USA. Andrey has been involved with photography since an early age but never owned his own darkroom. In 2000 Andrey purchased his first digital camera and hasn't used film since. Today he uses a Canon 10D digital SLR camera.

pages 91, 123

www.andrey@tigry.net

Ilona Wellman lives in Gummersbach, Germany. Ilona categorises herself as a digital artist and sells her prints through her website or through a stock library. She prefers to shoot everything digitally as she can see the results immediately after capture. Her final images are edited in Photoshop 7, Paint Shop Pro or Photo Impact. Ilona uses Canon 300D, Nikon 5700 and Canon G2 digital cameras.

page 43

IlonaWellmann.meinatelier.de

Darwin Wiggett is a professional photographer based in Alberta, Canada. Darwin and his wife **Anita Dammer**, set up Natural Moments Photography Ltd. Together they specialise in landscape, nature, animal, humour and child photography. Anita and Darwin are also the Editors-in-Chief of Canada's 'Photo Life' magazine.

pages 92–93, 94–95

www.portfolios.com/NaturalMom entsPhotography

Martin Woods is a digital photographic artist based in Southport, UK and has been shooting with digital cameras for the last four years. Being able to see the shots instantly gives Martin reassuring feedback that everything is OK and it also inspires him to develop his ideas further. Martin currently owns a Nikon 8700 digital camera

pages 128–129

www.martinwoods.co.uk

glossary

24 bit A measure of image colour depth. 24 bit is the most common bit depth for true photographic quality. Each of the three colour channels RGB (Red, Green Blue) holds 256 shades of its hue. 256 x 256 x 256 = 16,7772 colours.

36 bit A measure of image colour depth. Scanners often offer 36 bit scanning. This means that each of the three colour channels RGB (Red, Green, Blue) holds 12 bits of information which means 4096 shades of each hue, which equates to billions of colours.

48 bit A measure of colour depth in which each colour channel holds 16 bits of information.

32X speed This is a read/write speed generally associated with CD writers. Writers are listed as 48X/12X/52X – the first figure indicates the CD/R write speed, the second is the CD/RW write speed and the third is the CD read speed.

6500K A measure of colour temperature. Daylight conditions vary from between 4000 and 7500K. Most monitors are balanced to 5500 or 6500K to simulate daylight. Domestic lamps are roughly 2900K.

Aberration An image defect caused by a camera lens. These are usually visible as coloured edges on fine details in an image and are more pronounced at the edge of an image.

Actions A series of commands that are automatically executed in Photoshop. Other imaging applications may refer to them as scripts. Actions are useful for common tasks such as rotate or convert to another colour mode etc. The real benefit of actions will be appreciated on more complex tasks such as applying multiple filters.

Anti-aliasing The jagged edges in digital pictures are smoothed out by adding softer-toned pixels.

Application Another name for a software program.

Artifacts The flaws in a digital image. The most common flaws are JPEG artifacts, these are caused by over compressing an image.

Background printing A document is that is being printed whilst you are working on another task.

Back-up A duplicate of an image, folder or drive. Making regular back-ups should be a high priority in any workflow.

Banding A stepping effect in a smooth area of a picture, often a result of not having a high colour depth. Dithering can be used to minimise the effect.

Barrel distortion The curvature distortion caused by a wide-angle lens, this is particularly prominent in wide-to-telephoto zoom lenses.

Batch processing The act of applying a similar adjustment to a series of pictures. An efficient way to use this is by creating an action and applying it to a set of pictures.

Bit A single unit of data used in computing.

Bit-depth The generic term for describing how many colours an image can display. Generally photo quality is 8 bits per colour (RGB) which equals 24 bit colour.

Bitmap Digital photographs are bitmapped images. Bitmapped pictures are made with a series of pixels neatly arranged in rows and columns, each pixel having a unique place and value within a digital picture.

Bubblejet A term used for an inkjet printer.

Byte 8 bits of data make one byte.

Canvas The picture area within an image-editing or drawing application. This is the actual workspace for image manipulations.

Card reader A small device that connects to the computer, usually via a USB or Firewire connection, which allows the transfer of data from a memory card to computer.

CCD Charge coupled device. A chip that converts light into electrical signals, this is the central part of a digital camera and scanner.

CD ROM A compact disc which contains data. ROM stands for read only memory.

CD writer (or CD Burner) A compact disc drive that also writes to recordable CDs.

CD-R A compact disc which can record data once.

CD-R/W A compact disc which can be erased and re-written with data.

Chromatic aberration The colour fringing seen at the edge of a picture, usually caused by the light waves not meeting at the same point.

Clip art A small royalty-free illustration that can be incorporated into a document. Clip art in imaging applications has limited

use. Many entry-level applications are supplied with thousands of pieces of clip art.

Clipping Parts of an image that can't be accurately printed are clipped, often these parts will be highlighted with a contrasting colour to warn you.

Cloning tool Possibly the most important tool in any imaging application, also known as the rubber stamp. The Clone tool copies a portion of an image, defined by the brush size, and pastes it to another location. The copy-paste routine is a continuous process giving the impression that the user is painting with an image.

CMYK Cyan, magenta, yellow and black colours. These are printer colours as opposed to display colours (RGB)

Colour management A system that allows you to compensate for the colour variations between the various devices in the digital workflow. For accurate work you should have a fully colour managed system

Colour picker Or eye dropper tool, is used to select a colour.

Colour space Windows works with RGB colour space, professionals and colour labs prefer to work in the Adobe 1998 colour space.

Colour temperature The measuring of a light source in degrees Kelvin, The lower the temperature the redder the light. The higher the temperature, the more blue it is.

CompactFlash A digital camera memory card. Compact flash cards are available from 8mb through to 4gb.

Compression A process where digital files are reduced in size by compressing the image data into a smaller space, this can also mean a loss in quality.

CPU Central processing unit. The device that is at the heart of a computer. The CPU receives instructions, evaluates and performs calculations based on the software application in use and then issues instructions to other parts of the

computer system. It is often called the chip.

Crop To remove unwanted areas of an image to improve the composition or to make the image fit a specific size.

CRT Cathode ray tube; CRT monitors are bulky but still offer the best solution for accurate colours.

Curves A user-definable graph that can be used for adjusting the contrast, colour and brightness of an image by pushing and pulling a line

Descreen Taking out the halftone pattern from a printed image during scanning to avoid a moiré effect.

Digital zoom A method for increasing the range of a digital camera lens. This is a software solution and the results will be inferior to a true optical zoom lens. Avoid using the digital zoom setting, resizing a cropped image will have the same effect.

Digitise To convert an analog image (film) or sound into a digital file.

Dithering A process used to simulate colours. Red and yellow pixels placed close together will give the effect of an orange colour, black and white pixels will appear to be grey.

DPI Dots per inch, a term used for defining the resolution of a printer or scanner. The higher the dpi, the more photo-realistic the picture will be. The term DPI is often misused with digital images on screen, these should be referred to as PPI (pixels per inch)

Driver A small software application that enables a printer, scanner, camera etc. to be recognised and operated by a computer. You should periodically check on the web for updates to drivers.

Drum scanner A high-end scanner. Film is placed on a drum, which is spun at a high speed and a laser light is transmitted through the film to produce a digital file.

DTP Desktop publishing applications are used for designing and laying out pages ready for publication.

Duotone A process that uses two inks to increase the tonal range of a print. Photoshop has a duotone setting that allows the mixing of two colours to

produce toned prints (Sepia). Tritones and Quadtones use three and four colours respectively.

DVD Digital versatile disc, this is rapidly becoming the new standard for storing large amounts of data. A DVD disk will hold up to 4.7GB of data.

Dye inks Most inkjet printers use dye-based inks, these are rapid drying and produce vibrant colours but are generally not suitable for long-term archival printing.

Dye sublimation A process where a coloured ribbon is evaporated into gas which transfers to the media and re-hardens. At one time this was the best choice for photo-quality printing.

Dynamic range The tonal range that can be captured by a scanner or camera.

EPS Encapsulated postscript is an image or page layout file that can be read by a wide variety of professional applications such as DTP, Illustrator and Photoshop.

Eye dropper tool An imaging application tool used to sample or choose a colour.

Feathering A process to soften the edges of a cut-out. Generally a two or three pixel feathering on a selection will prevent it from looking jagged.

File extension A three or four letter suffix that defines the file type, e.g. .JPG, .TIFF, .EPS.

Film scanner A scanner dedicated to scanning film. The most common is 35mm, which will scan in positive and negative film.

Filter In traditional film photography this was a piece of coloured glass placed in front of a lens. In digital photography this refers to a special effect in an imaging application.

Firewire A high-speed port that allows fast transfer of data between devices such as digital cameras, camcorders, CD writers, scanners, printers and computers. Most current computers are supplied with Firewire, if not then accessory PCI cards with FireWire ports can be purchased for a modest price. Also known as IEEE 1394.

Gamma A method for setting the contrast on a monitor. Windows uses 2.2, Macs use 1.8.

Gamut The amount of space colours occupy, an extended gamut will increase the amount of colours that can be displayed or printed.

Gif Graphic interchange format. compressed file format that is used for displaying graphics on the internet, perhaps not the best choice for photographs as it will only display 216 colours.

Gigabyte 1,073,741,824 bytes (about a billion) make a gigabyte (GB).

Grain The small particles of silver that make up a film emulsion. The digital equivalent is noise.

Graphics card An internal card that is responsible for sending the signal to a monitor.

Greyscale An image that is made up from tones ranging from black (0) to white (255). Also referred to as b&w pictures.

Halftone A unit used to simulate grey by a printing system that is only capable of printing in black or white. Small black dots placed close together on white will produce a grey, increase the spacing and the grey will be perceived as a lighter tone.

Hard drive The internal drive in a computer that is used to store the operating system, applications and data. For imaging computers a 80gb drive should be regarded as the minimum.

Healing brush A Photoshop tool that is similar to the clone tool, but is smarter. This tool is invaluable for portrait retouching.

Highlight The lightest part of an image, a value of 255 is totally void of any detail. Aim to set a maximum highlight value of 245 to 250.

Histogram A graphical interpretation of the image file. Knowing how to read a histogram on a digital camera will assist you with setting the correct exposure.

Hue/Saturation The hue is the shade of colour, the saturation is the intensity of that colour. Pictures can be enhanced by increasing the saturation.

ICC profiles Colour profiles that meet the specifications as laid out by the ICC (International Colour Consortium) standards. Essential for colour management.

Inkjet The most common form of printing. A small amount of ink is heated, causing causes it to explode and settle on the media. This process happens thousands of times every second and produces the final picture.

Interface The way an application or operating system is graphically presented on screen.

Interpolation A method for increasing the actual image size. Interpolating an image adds extra pixels based on the values of the surrounding pixels and will not produce the same image quality that can be obtained by using a larger capture device.

ISO A measure of light sensitivity. Most digital cameras will produce the best quality at a setting of 100–200 ISO, a higher value may introduce 'noise' in the darker areas.

Jaggies Edges of an image that are clearly displaying stair-stepping pixels, usually a small amount of feathering or anti-aliasing is sufficient to remove the jaggies.

JPEG Joint photographers expert group. Also known as JPEG, this is a file format that is used for compressing image files down to a much smaller size. Compression will sacrifice image quality but produce a smaller file size. Avoid using the JPEG format for work in progress.

Kilobyte 1024 bytes make one kilobyte (KB) thousand.

Lab A method for describing a colour space. Lab mode is not used by hardware.

Layers A very powerful feature that enables different elements of a picture to be stored on a layer in an imaging application. Layers allows the user to move or turn off the individual element without affecting other parts of the image.

LCD Liquid crystal display, a small screen on the back of a digital camera that enables the user to view their pictures. The LCD screen will not perform well in bright sunlight but using the histogram will assist in this case.

LCD monitors An ultra thin monitor that occupies very little desk space. These are gaining in popularity for imaging work and the image quality is on par with CRT monitors.

Levels An adjustment tool for setting the highlight, midtone and dark areas of a picture. The levels interface has a histogram for visually setting the correct points.

Line art An illustration made with black lines.

Lossless compression A method for compressing images without loosing any quality. The most common is a LZW TIFF file. Photoshop's own file format PSD will also apply a small amount of lossless compression.

Lossy compression A compression that will sacrifice image quality in order to produce a smaller file size. JPEG is the most common lossy format.

LPI Lines per inch; a measure of resolution for photomechanical reproduction.

Magic wand A tool used to select similar areas of colour. Values can be changed in order to include more or less of the surrounding colours. This tool has its limitations for making a complex selection.

Magneto optical A removable storage device that will hold 230mb, 640mb or more of data. Although a very stable device for long-term storage, they have been largely replaced by the CD-R.

Marquee tool A tool for making rectangular, square, elliptical or circle selections.

Megabyte 1,048,579 bytes make a megabyte (MB) million.

Megapixel A term used by digital cameras. A megapixel is roughly one million pixels. High-end digital cameras are now using 14Mp chips. Consumer cameras are catching up with 6 and 8Mp cameras.

Memory A term used for the amount of space available on a Memory card or the amount of RAM fitted in a computer.

CompactFlash cards These drives have a capacity of 340MB through to 4GB, the downside on these are they are heavy on battery usage.

Optical resolution The actual resolution offered by a scanner. Some manufacturers quote a high interpolated resolution on the box, but the real figure to look out for is the optical resolution.

Optical viewfinder The viewfinder window used for composing a picture. A good viewfinder will have a diopter adjustment and the facility to compensate for close-up work.

Operating System (OS) Windows XP, ME, 98 or 95, Mac OS X or 9.2 etc. The system that enables you to work on a computer.

Photo CD A disc containing images, each image has six resolutions from 64 x 96 (thumbnail) through to 2048 x 3072 (18MB). The Photo CD didn't corner the main market due to falling prices on film scanners.

Pigment inks A very stable ink made from pigments. Many art photographers are using pigment ink printers due to their archival qualities. A pigment ink print will last for about 100 years, dye prints can last from one year through to about 30 years.

Pincushion distortion A distortion common to poorly designed telephoto lenses. The edges on the image appear to be pulling inwards. This can be rectified with the pinch filter in Photoshop.

Pixel A picture element. A digital image is made up from millions of pixels.

Pixelation A term used for images that are too low in resolution, so the pixels become visible to the naked eye.

Plug-ins Mini applications within Photoshop that will apply an effect to the image. Photoshop and other imaging applications are supplied with a set of filters, but there are many other third party software companies that sell more specialist filters.

PNG Portable network graphics, a versatile file format that will support Lossless files for use on the internet. File sizes are still too large for practical use.

PPI Points per inch, a unit used by scanners to define quality. A higher PPI will result in more detail being rendered. A great deal of confusion still hangs over DPI, PPI and LPI, this is mainly down to inaccurate use of each.

Profiles The colour characteristics of an output or input device. Colour profiles are

created with specialist hardware and software. A system that is fully colour managed will make use of a profile to ensure accurate display and printing of colours.

PSD Photoshop's native file format. A file saved in PSD format will preserve layers contained within an image, this makes it an ideal format for saving work in progress files.

RAM Random access memory. A temporary method for storage of data, usually the work on screen. The information is cleared when the computer is turned off.

Removable media Any media that allows data to written to it and can be removed from the computer. This includes Zip drives, CD discs, Optical discs and DVD.

Re-sampling To up- or downsize an image.

Resolution The term used to define the image size. A high-resolution image contains more information than a low resolution image

RGB Red, green and blue. The colours used to display an image on a monitor screen. Each colour has 256 shades – 256 x 256 x 256 = 16.7 million colours

RIP Raster Image processor. This translates vector graphics and fonts into bitmap images.

ROM Read only memory. This type of memory cannot be written to, a CD-ROM is one such case (CD-Rs can be written to).

Rubber stamp Photoshop's name for the clone tool. Probably the single most useful tool in any imaging application.

Scratch disk A reserved space for the temporary storage of work in progress. An area of hard disk space can be defined just for Photoshop work, this will speed up the imaging workflow.

Scripts See Actions.

SCSI Small computer systems interface. A standard for connecting scanners and other devices to a computer. This has been largely replaced by USB 2 and Firewire.

Selection An area that has been selected with the magic wand or marquee tools, often known as 'the marching ants'.

Sharpening An increase in contrast on the edges of an image, making it look sharper than it actually is.

SmartMedia A flat memory card used in a digital camera for storing images.

Software The applications that a user installs on a computer.

Thumbnail A small picture used on a web page.

TIFF Tagged image file format. A good cross-platform image file format that is compatible with most applications. TIFFs can be compressed using the LZW lossless option.

TWAIN An interface to enable a computer to control a scanner.

Unsharp mask (USM) A sophisticated method of sharpening images with plenty of user controls.

USB Universal serial bus. A standard for connecting devices to a computer. High Speed USB 2.0 is the latest version.

White balance Use the custom white balance on a digital camera to achieve accurate colours. The process is simple, just point the camera at a sheet of white paper and press the shutter release.

ZIP A compressed data file, ideal for sending large files over the internet. However, it will not reduce image files by a great amount.

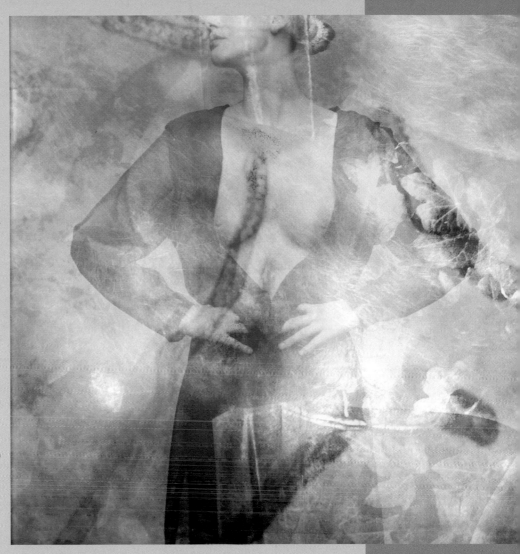

'Verlangen' by Theo Berends

web links

1/ Nature Photographers

A website dedicated to all aspects of nature photography, landscapes and wildlife. The site features galleries and a discussion forum.

www.naturephotographers.net

Nature Photographers Online Magazine

Photo Critique Galleries and Photography Discussion Forums · Photographic Accessories and Reviews
Wildlife, Landscape, Nature and Digital Photography Instructional Articles

ENTER · SITE MAP · SITE TOUR · TERMS OF USE

Welcome to *photo-i*, a dedicated site for digital photographers. Just to keep you all in the picture, I haven't died (yet). I have been busy on a couple of big projects including writing a book on Advanced Digital Photography. This has kept me away from photo-i, but ensures that my bills are paid. I will be adding a new section devoted to Colour Management during April and will be adding a couple of printer reviews, these will have a new feature which I am sure you will like.

Vincent Oliver - Wednesday, April 7, 2004

interactive review

The Canon i965 updated 7/04/04

EPSON prints will last for **1000** years says
Henry Wilhelm

HP 30 for **big** boys & girls

welcome
news
reviews
talkshop
interviews
creative-i
techniques
beginners
exhibitions
web-links
contact us
forum

© Vincent Oliver 2004

BizRate *shopping search*
Find the lowest price on the latest Digital Cameras
Canon · Fuji · Minolta · Nikon · Olympus · Sony

d.review.com

Nikon D70

in-depth review

3. Body & Design

Body & Design

News
Reviews
Cameras
Timeline
Buying Guide
Galleries
Forums
Search
Learn
Glossary
Feedback
Newsletter
Links
Support Us
About

140 mm (5.5 in)
78 mm (3.1 in)
111 mm (4.4 in)

4/ Rob Galbraith

Rob's website contains lots of useful information and reviews for the professional or advanced photographer.

www.robgalbraith.com

5/ The Luminous Landscape

A useful resource for landscape photographers that has many excellent tutorials and reviews.

www.luminous-landscape.com

Rob Galbraith Digital Photography Insights

Digital photography news, reviews, tutorials and discussion forums for professional photographers

Top Story

The EOS 20D
Canon unveils 8.2MP, 5 fps entry-level pro digital SLR

Home
Events
CF Database
Resources
About
Contact
Forums
Advertising

SEARCH
search news GO
search forums GO

The Camera Store
1-888-339-0307

Introduce
ATP High Speed
60X SD

ARCHIVES

‹ August › ‹ 2004 ›
S M T W T F S
1 2 3 4 5 6 7
8 9 10 11 12 13 14
15 16 17 18 19 20 21
22 23 24 25 26 27 28
29 30 31

News

Canon announces Speedlite 580EX
Canon today has announced the Speedlite 580EX, a replacement for their flagship 550EX flash unit. It's expected to ship in October.
August 19, 2004 | FULL STORY ›

Advertisement

Digital Workflow Seminars
Learn what to do after you've taken the picture. www.puredigitalfun.com

Lexar 80X, Kingston Elite Pro, Transcend 60X added to CF Database
The CompactFlash Performance Database has been updated to included in-camera write speed and card-to-computer transfer rate data for Lexar Pro Series 80X and Kingston Elite Pro CompactFlash cards, as well as SD cards from Transcend and Kingston. Prospective purchasers of Lexar 80X cards in particular will want to read the section in this article entitled Some Lexar 80X are More Equal Than Others.
July 29, 2004 | FULL STORY ›

Caribbean Click II sets sail with me, Kevin Gilbert on board

QUICK LINKS

► Web sites post photos taken with the EOS 20D (View)
► Tom's Hardware: cheap dual-monitor via USB port (View)
► EliedaLive: Philips announces 16X DVD+R media (View)
► Canon announces 10-22mm, 17-85mm EF-S lenses (View)
► Nikon Pro: traveling light, SB-800 multi-flash, WT-1A transmitter (View)
► DOP: review of Correct Editlab Pro 4.5 (View)
► August issue of Digital Journalist posted (View)
► Olympics photo galleries started (View)
► PDN: New York Times issues new stock agency contract (View)
► DOP: Photoshop lens blur filter tutorial (View)

Homepage | Search | Contact

The Luminous Landscape

Available Workshop & Seminars | Tutorials | Shooting Locations
Essays | Product reviews | Regular columns
Understanding Series | About This Site | The Video Journal

About The Video Journal

What's New | Contents | Discussion Forum | Vita a Next-Generation Digital Camera

© 1995 2004 Michael Reichmann

Blended Exposures

— Achieving an 8-10 Stop Dynamic Range —

*This article from 1999 has now been superceeded by a newer one that details
three different blending techniques that are more appropriate for digital photographers.*

The Problem

Colour transparency film has a useful dynamic range of about 4-5 stops between the lightest area with any detail and the darkest. Beyond that is found featureless black or transparent white. Colour negative film has a couple of additional stops and B&W film another stop or so. But, nature can present the landscape photographers with scenes having a dynamic range of 10 stops or more — double that which slide film can handle

2/ Photo-i

A magazine-style website covering all aspects of digital photography with an emphasis on printer and scanner reviews. The site has an active discussion forum and features unique interactive reviews.

www.photo-i.co.uk

3/ Digital Photography Review

A great resource. If you want to know anything about the latest digital cameras then this is the site to visit.

www.dpreview.com